TATTOO MASTERS

Edited by
Lal Hardy

First published in Great Britain in 2015 by LOM Art, an imprint of
Michael O'Mara Books Limited
9 Lion Yard
Tremadoc Road
London SW4 7NQ

A CIP catalogue record for this book is available from the British Library.

Papers used by Michael O'Mara Books Limited are natural, recyclable products
made from wood grown in sustainable forests. The manufacturing processes
conform to the environmental regulations of the country of origin.

ISBN: 978-1-91055-208-7 in hardback print format

1 2 3 4 5 6 7 8 9 10

Cover design by Ana Bzejancevic
Designed and typeset by Design23, London
Printed and bound in Malaysia

www.mombooks.com

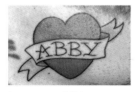

In memory of Abby

CONTENTS

INTRODUCTION

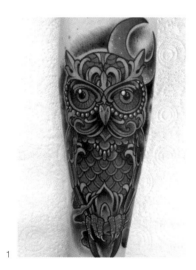

1

When I was asked to compile a book of tattoo artists I feel have created inspirational work that has influenced the tattoo world, I had to tell the publisher that this would be impossible unless future volumes were planned: the quality, diversity and sheer talent found in the global tattoo community today is truly too immense for just one book. For this volume I have selected a variety of artists and tattoo styles reflecting the diversity found in the tattoo scene. The timeline covered ranges from the legendary George Bone, who has been tattooing for 50 years, to the likes of Ryan Evans, who has been plying his trade a mere four years.

In my early days one only tended to see tattoos in the flesh, or occasionally in risqué magazines, an occasional *National Geographic* article or in the more sensationalist press. Some photos were exchanged but the trade was largely closed and insular – almost a secret society. A world without the likes of Twitter, Pinterest, Facebook and Instagram must seem unimaginable to people today!

By the mid-1980s tattoo conventions had started to take place across America, Europe and Australia. Now they are found worldwide: as I type this, one convention was underway in Nepal when the devastating earthquake struck! A plethora of tattoo magazines also emerged, printing work of all styles, and bringing tattooing to a bigger audience. Many carried adverts for tattoo supply companies, allowing the public access to the 'tools of the trade', which were previously almost impossible to obtain.

Reality TV shows such as *Miami Ink*, *LA Ink* and *London Ink* sparked a boom in the tattoo trade – they drew large weekly viewing figures and were sold to numerous international channels. Instead of the words 'Tattoo Studio', many new businesses now chose simply to use the word INK with a prefix of their geographic location or name.

The past ten years have seen tattoo become so mainstream that it seems strange that in various countries, up until relatively recently, it was either banned or an underground art. The spread of the internet has seen tattooing

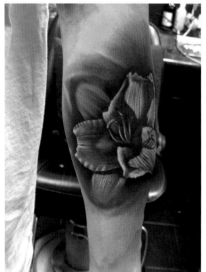

2

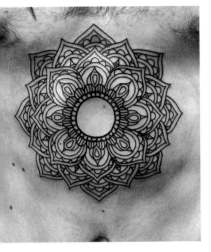

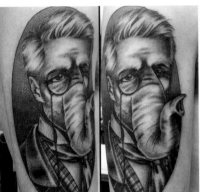

reach its biggest audience ever. Tattooing trends are often celebrity-driven. Once a celebrity's tattoo hits the net, it is bound to be copied extensively, a prime example being the angel adorning David Beckham's back, renditions of which can be found worldwide. Other images that appear online become widely adopted – at the time of writing, pocket watches are especially popular.

Every imaginable style of tattoo is now available: traditional iconic sailor or military designs; new school (image 1 by Angela Pelentrides); realism (image 2 by Dariusz Jujka); colour portraiture; tribal; sacred mandalas (image 3 by Claire Innit); the downright bizarre (image 4 by Sharnie Pilar); pop art; watercolour; Celtic; Japanese; comic book; manga; fantasy; births and deaths; love; hate; sports (image 5 by Angela Pelentrides); war (image 6 by Lal Hardy); celebrities; idols; subcultures; film and television; music (image 7 by Lal Hardy) . . . the list of subjects celebrated or documented through the tattooist's craft is endless!

This book features stunning work by some of the greatest names in the tattoo game and some of the newer artists who are already making their mark in the ancient, still somewhat mysterious and certainly fascinating art form that is TATTOOING.

Lal Hardy
London 2015

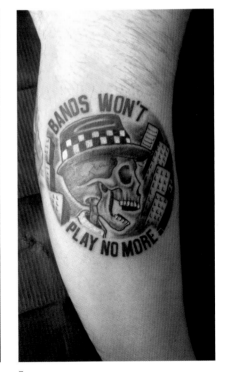

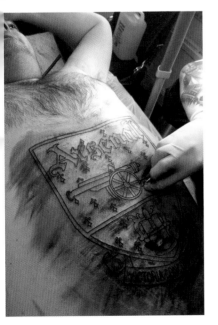

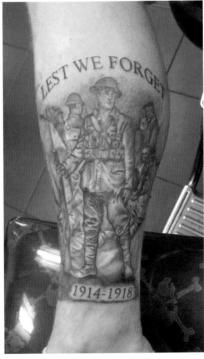

5

6

7

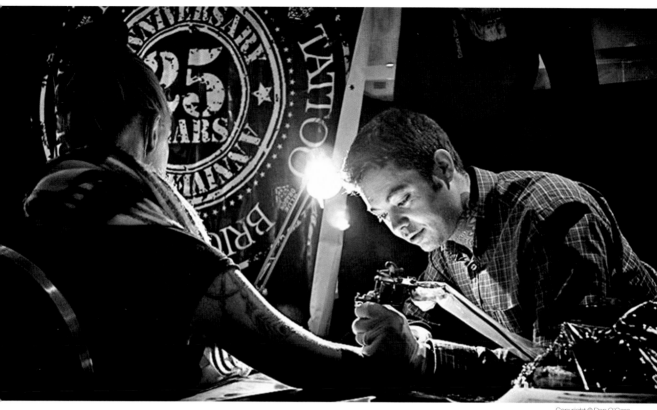

DOTWORK DAMIAN

Tattooing out of The Blue Dragon Studio in Brighton on Britain's south coast, Damian's appreciation of the pointillist style and particularly the works of M.C.Escher, Monet, Georges Seurat and Ernst Haeckel greatly influence his unique approach to his tattoo works.

Combining the intricate detail of dotwork with realism leads Damian to some interesting and challenging projects in these fields. He is appreciative of the support of the team at Blue Dragon, the trust of his customers and the love of his family, Amy and Luca.

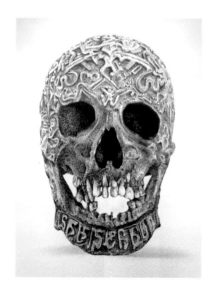

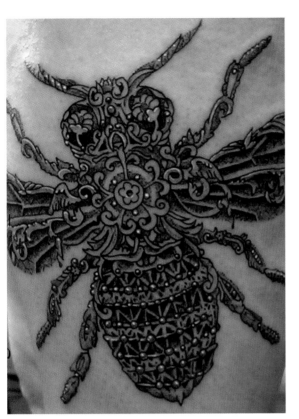

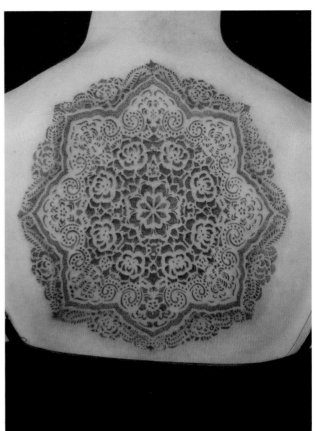

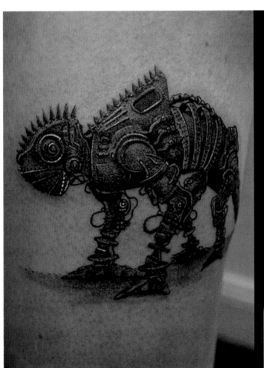

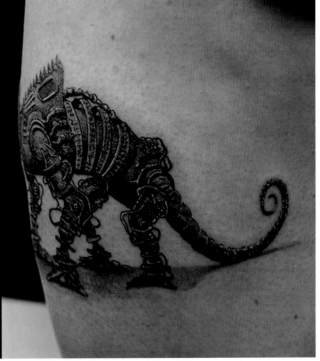

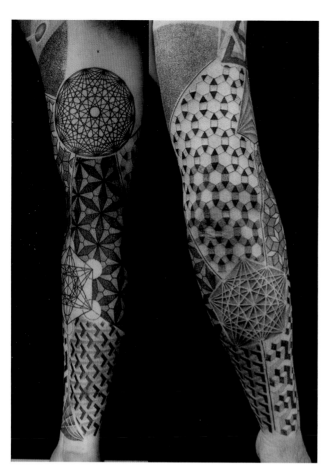

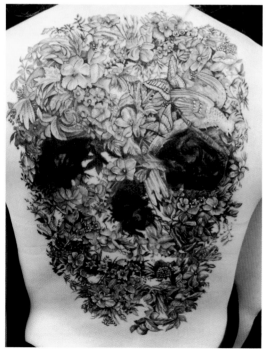

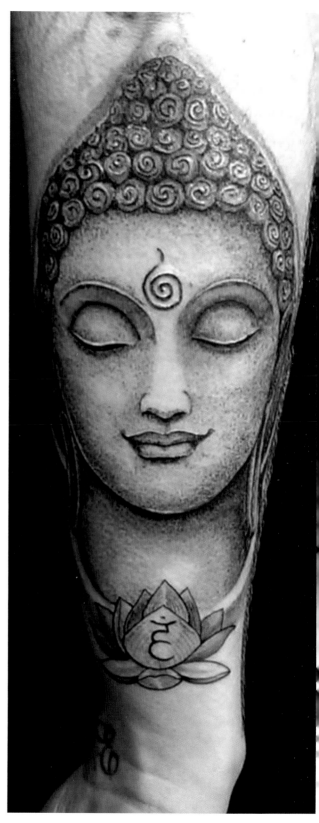

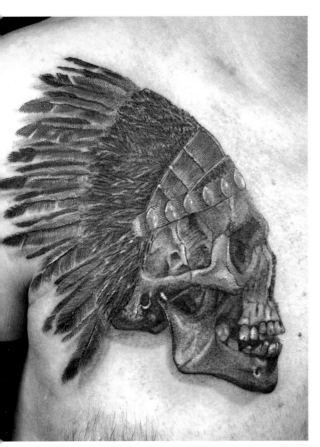

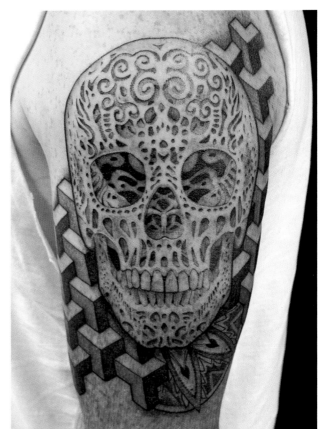

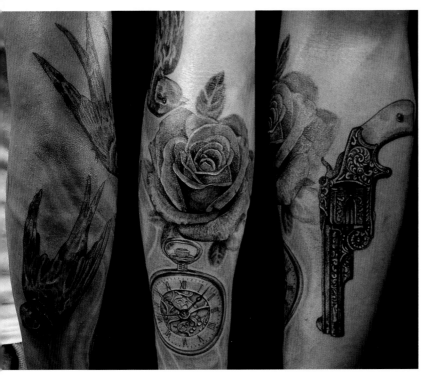

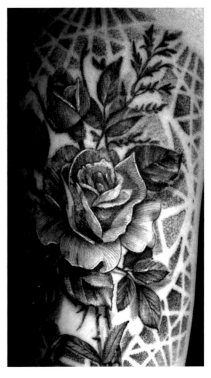

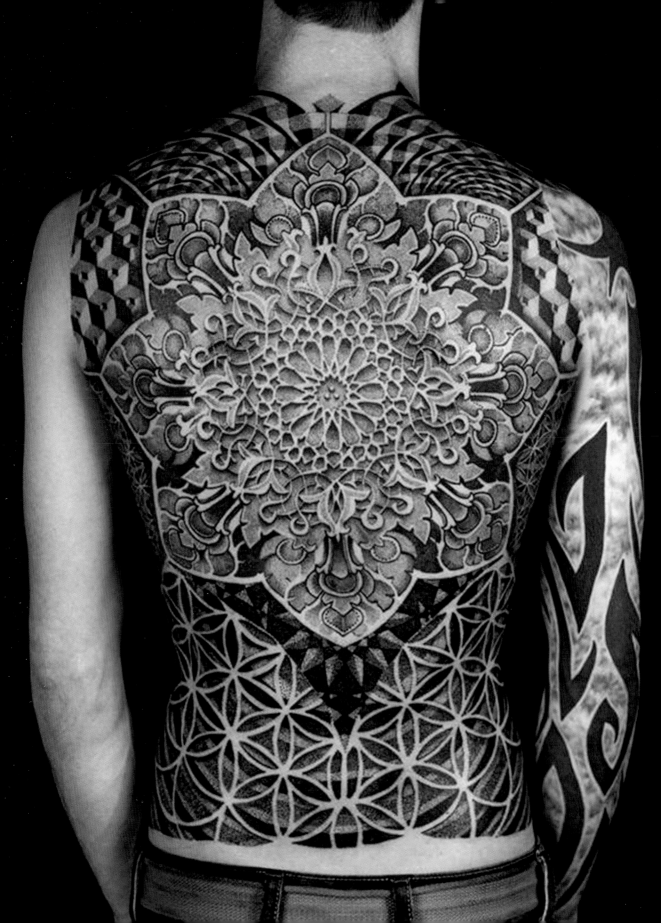

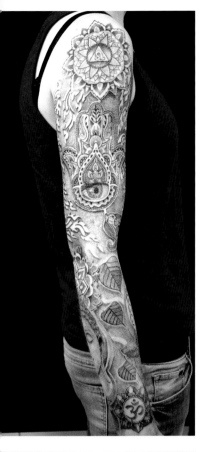

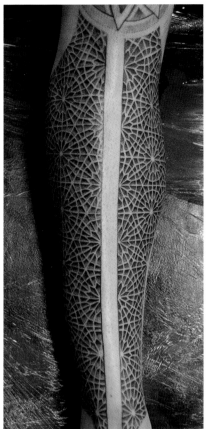

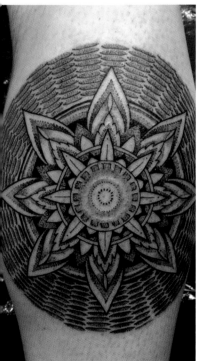

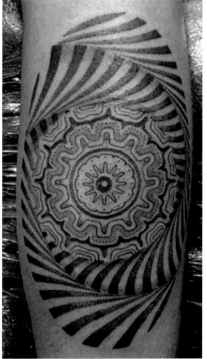

See more at
www.dotworkdamian.com

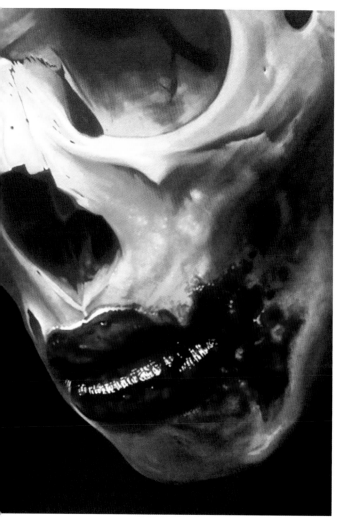

JASON BUTCHER

Jason is world famous as the creator of the genre of tattooing known as Death Romantic. In 1999, after tattooing for around five years, he opened Immortal Ink Tattoo Studio in Chelmsford, Essex. His Death Romantic style is often imitated but his signature is unmistakable in his pieces, not least because he is both artistically and technically accomplished. These pieces are remarkable for being ultimately paradoxical: at the same time they are ephemeral yet solid, spiritual yet prosaic. Portraying death through the lively animation of youthful life, they manage to be surreal as well as realistic. The longer one looks at them, the more the depth of the artist's thinking becomes apparent. He inverts the natural order of things by making the bones of the skull prior to the features, skin and muscle that it subsumes.

Jason has always been 'into horror' but admits that his style has developed and become more subtle, complex and sophisticated. He likes using meaningful themes in his tattoo work and enjoys his clients giving him a freer rein. He is currently collaborating with Lianne Moule (see p.20) and producing remarkably inventive tattoo works (see pp.17-19). Jason was previously known for his skill in working almost exclusively in black and grey but the collaboration work is a fresh challenge that allows him to expand his style and express himself on another level.

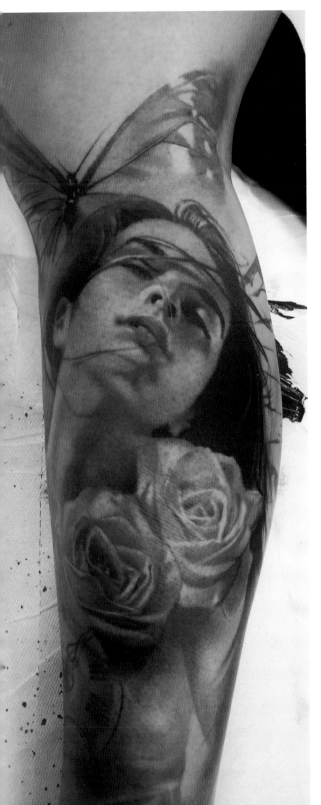

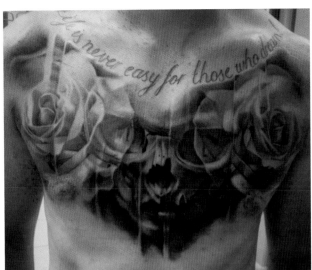

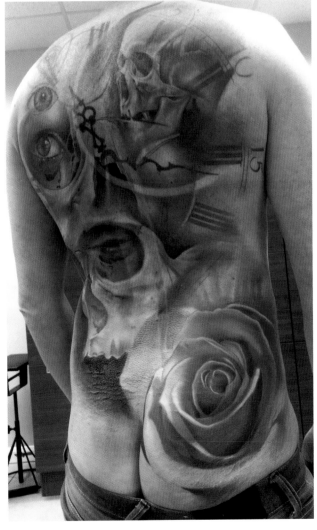

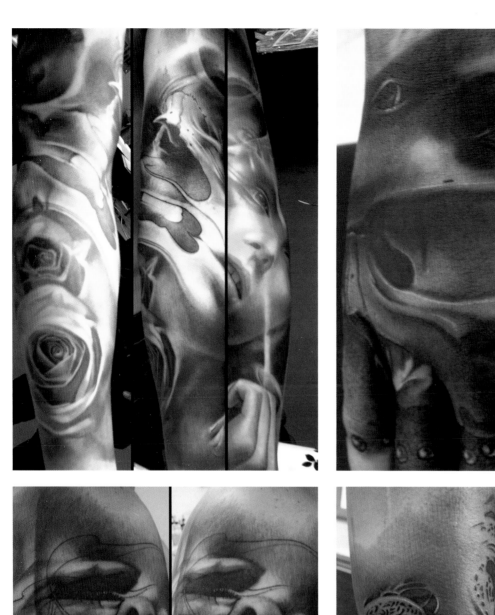
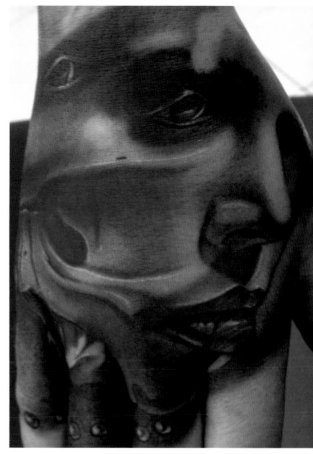
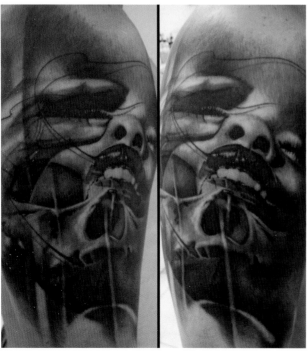
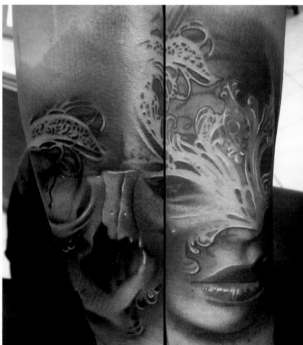

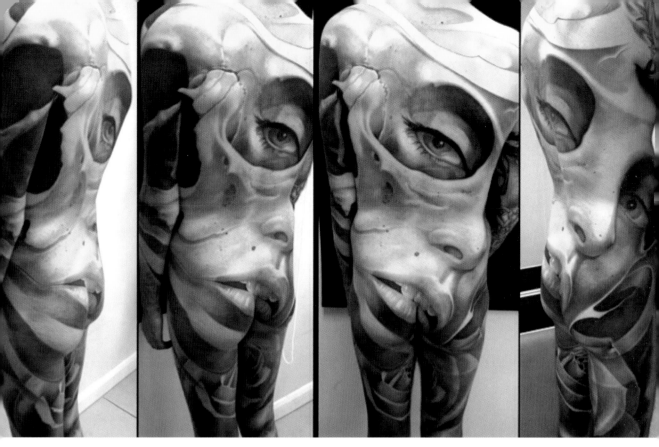

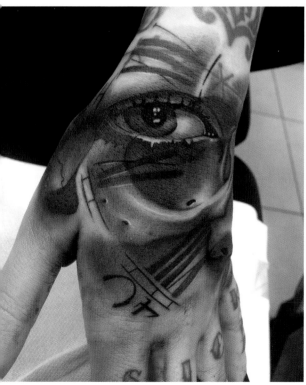

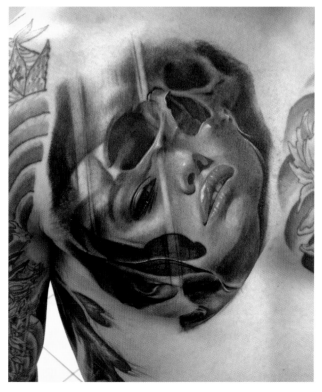

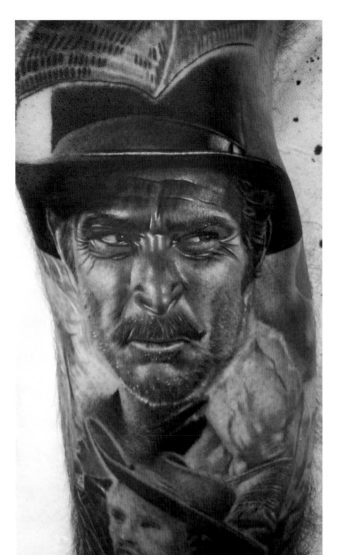

See more at www.immortalink.co.uk

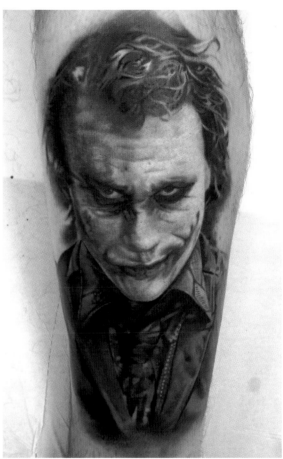

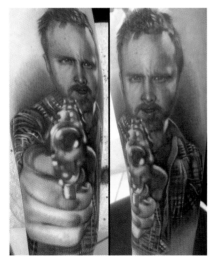

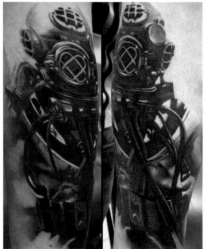

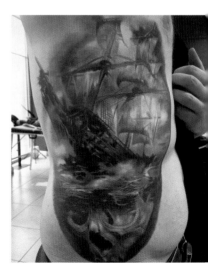

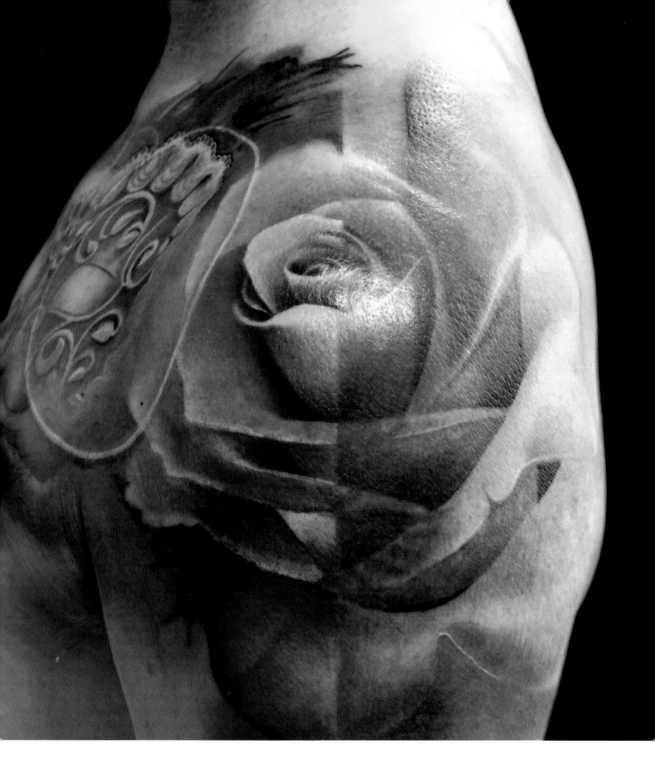

Jason Butcher (see p.12) and Lianne Moule (see p.20) needed a fresh new challenge to push and expand their styles. Their collaborations (above and overleaf) allow them to express themselves even more and to produce unique pieces that flow with the body.

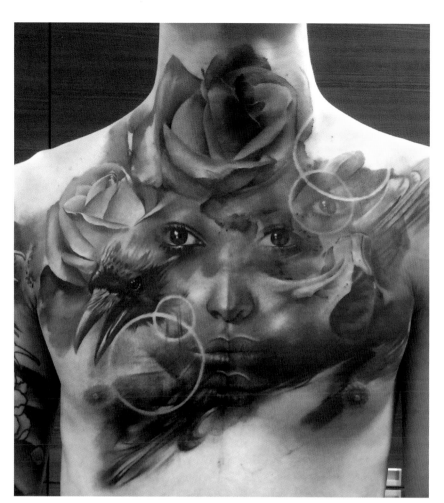

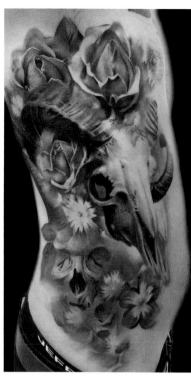

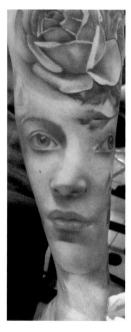

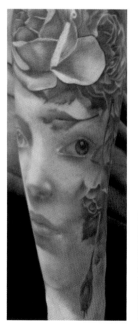

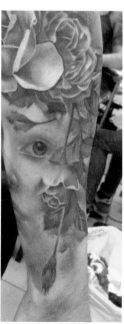

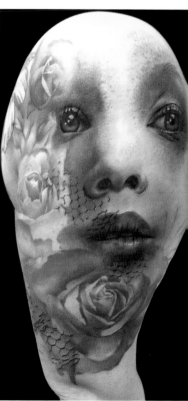

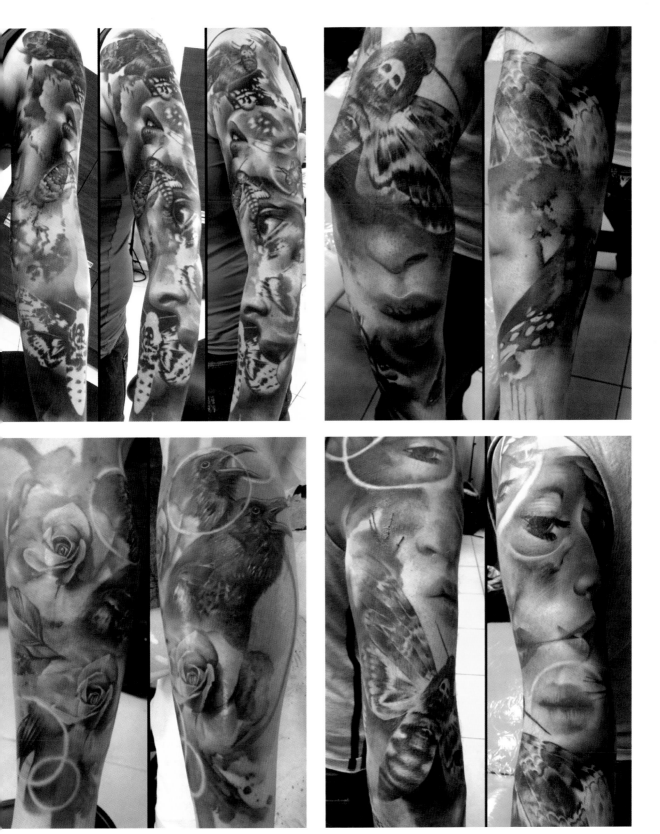

LIANNE MOULE

Best known for her watercolour tattoos, Lianne studied Fine Art at London's Byam Shaw School of Art, founded in 1910 by painter John Byam Shaw, a child protégé recognised by the Pre-Raphaelite painter John Everett Millais. In 2003, Central St Martins absorbed Byam Shaw. Lianne has an artwork retained in its Permanent Collection. She graduated with a Bachelor of Fine Arts degree in 2005, and went on to win the Young Artists category in the National Open Art Exhibition at Chichester in 2005. She was also shortlisted in the Professional Artists category of the UK Celeste Art Prize in 2006. While at art school, She was influenced by the art of Jenny Saville and Rembrandt.

Lianne is a versatile artist in various media, but started tattooing in 2008. She is best known for recreating watercolour paintings, using skin as canvas. Her working practice as a tattooist involves painting a study to use for reference. She loves to celebrate the natural world through her art. Whether on skin or paper, her art is achingly beautiful in both rendering and observation. She can capture sunlight, and weaves it through her creations, making her talent seem supernatural. Her compositions are edgy and daring, adding depth and layers of interest. Exquisitely faithful to nature, Lianne defiantly reminds the viewer of the medium, with wilful spills, splashes and drips, according to her artistic whim. These 'Lianne signatures', coupled with her immense skill, make her painterly works difficult to imitate.

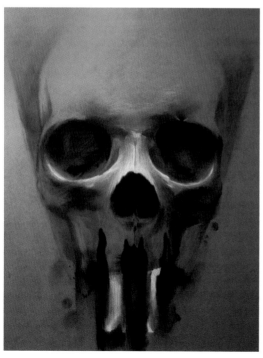

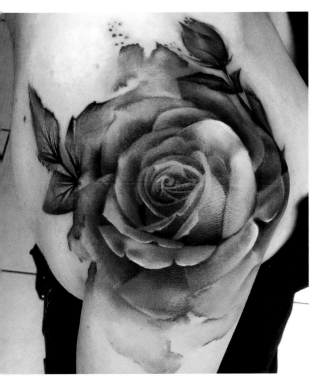

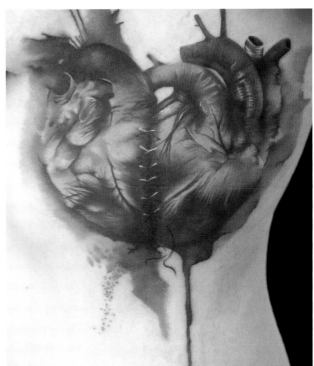

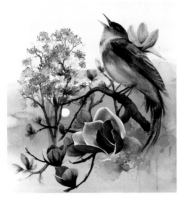

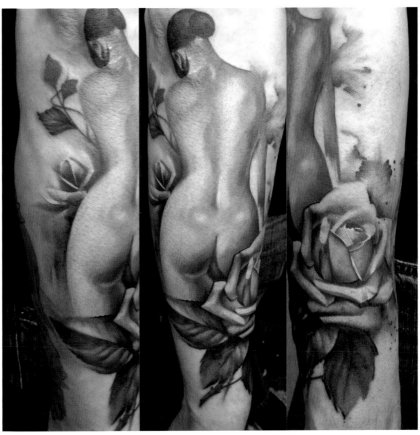

Artwork by Lianne

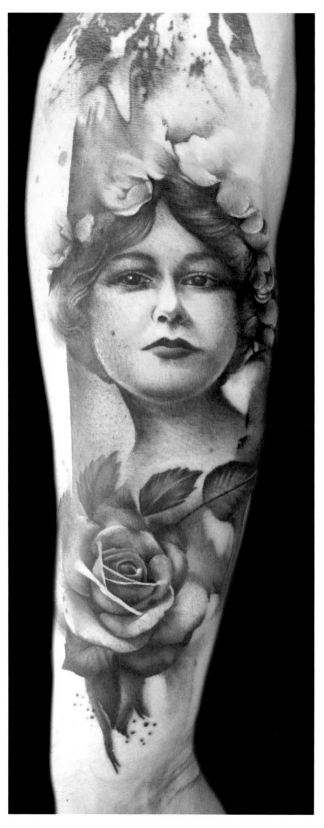

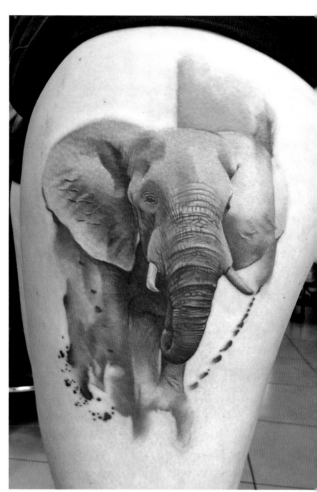

See more at www.immortalink.co.uk

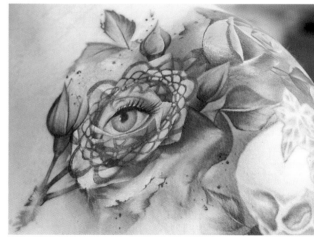

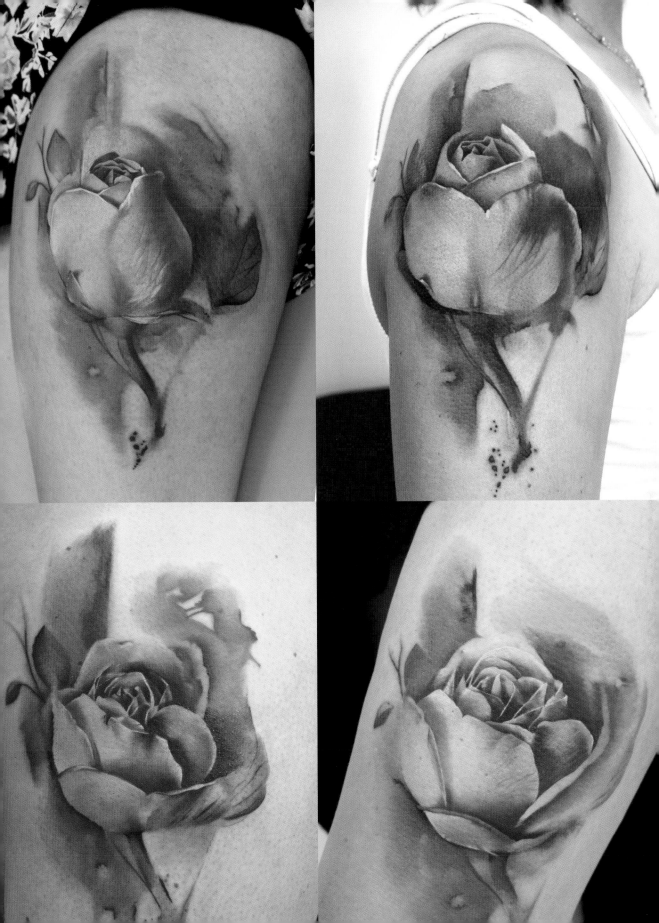

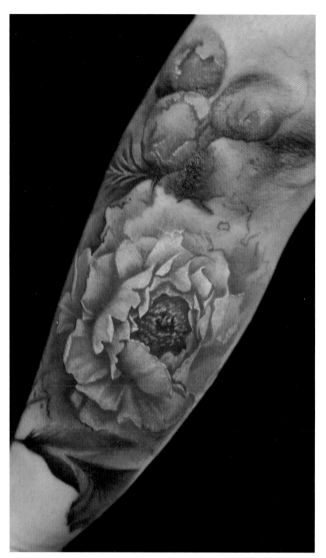

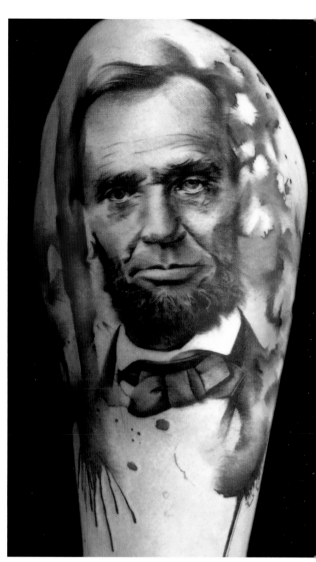

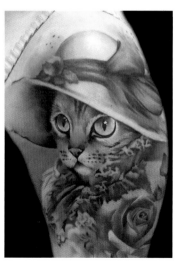

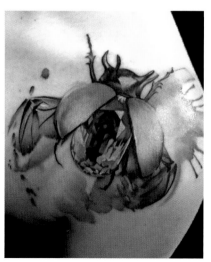

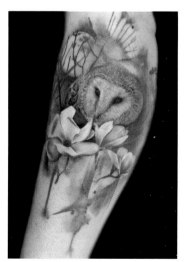

LOUIS MALLOY

Born in 1963 in Manchester, from a very young age I took an interest in tattoos after becoming intrigued as to why these 'drawings' on the skin didn't wash off. Growing up in a family where arts and culture was a focal point channelled me towards the visual arts with the main influence being tattooing. However, in the 1970s there was very little literature available and information was hard to come by. I got my first professionally applied tattoo at the age of 14 and acquired my first tattoo machine at the age of 16.

Telling my careers officer at school that I wanted to be a tattoo artist was not greeted with any enthusiasm. At the age of 18, in late August of 1981, I opened the Middleton Tattoo Studio where I remain to this day. The AIDS hysteria of that decade nearly finished things for me, like it did many other tattooists, but things did eventually get better. The 1990s are regarded by many as the golden years of tattooing but I saw this more as the decade when tattooing started to come of age. For me, the turn of the millennium was the start of what I thought was the golden age of tattooing, as this was the decade when tattooing became global on a scale that none of us from those early days could ever have imagined. In this decade, tattooing has changed and fragmented so much that I am not sure what tattooing is any more.

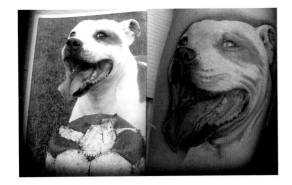

Despite the changes, I am privileged to be able to work in an industry that I love and have met some incredible people along the way. I hope that after I am long gone I will be remembered as one of the 'New Wave' of tattooists who helped dispel the common misconceptions of tattooing and made it more socially acceptable to be tattooed.

Louis Malloy

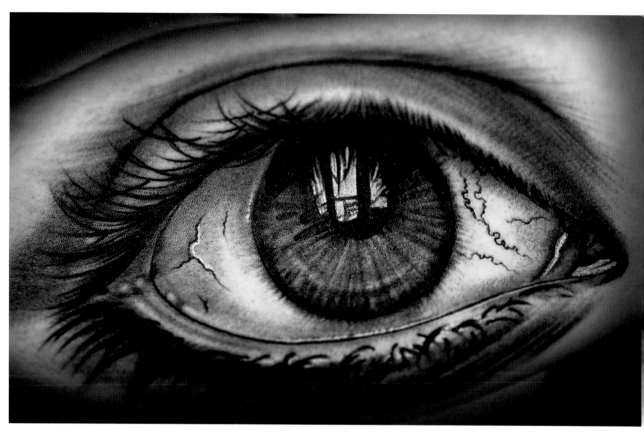

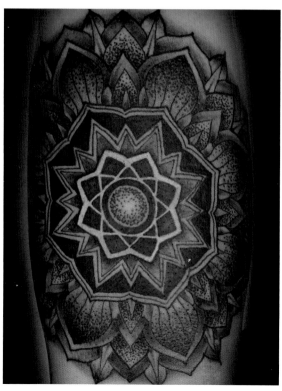

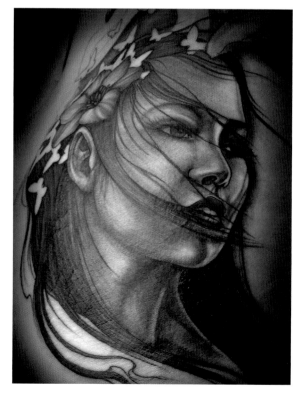

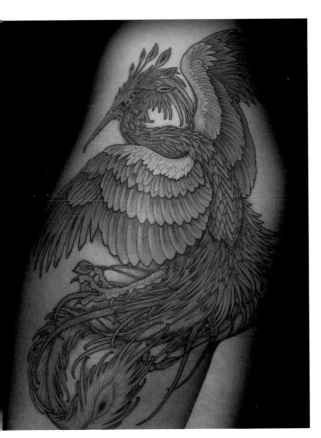

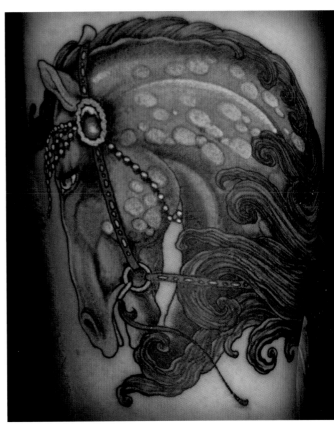

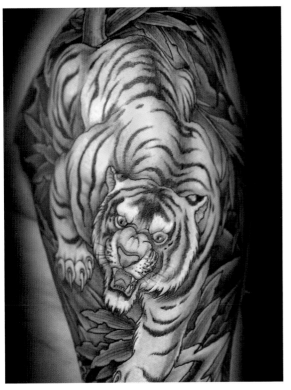

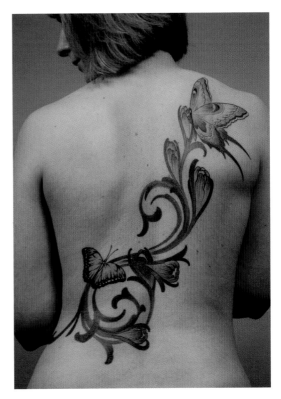

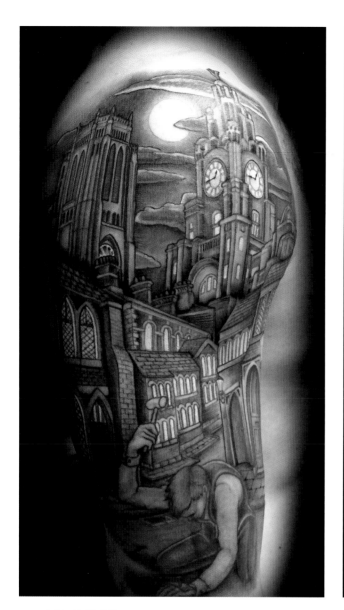

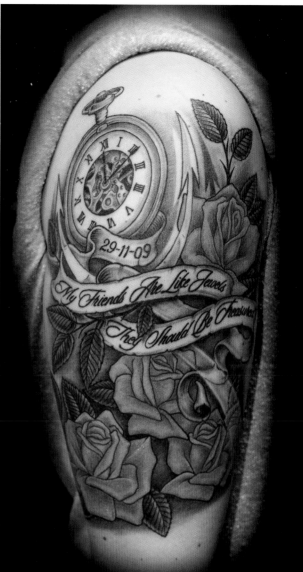

See more at www.tattoos.co.uk

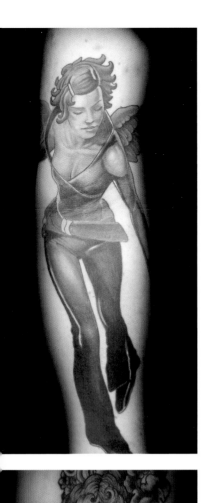

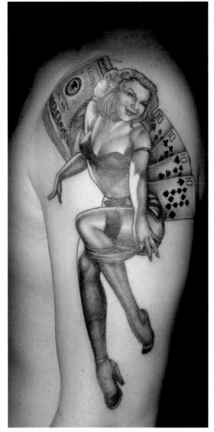

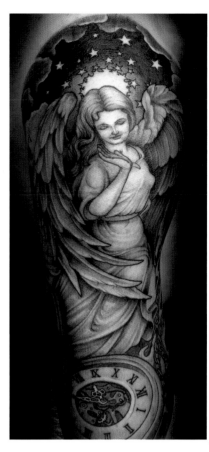

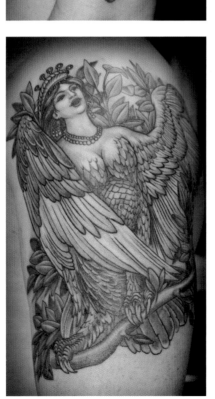

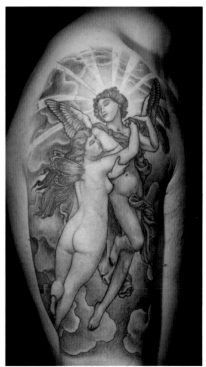

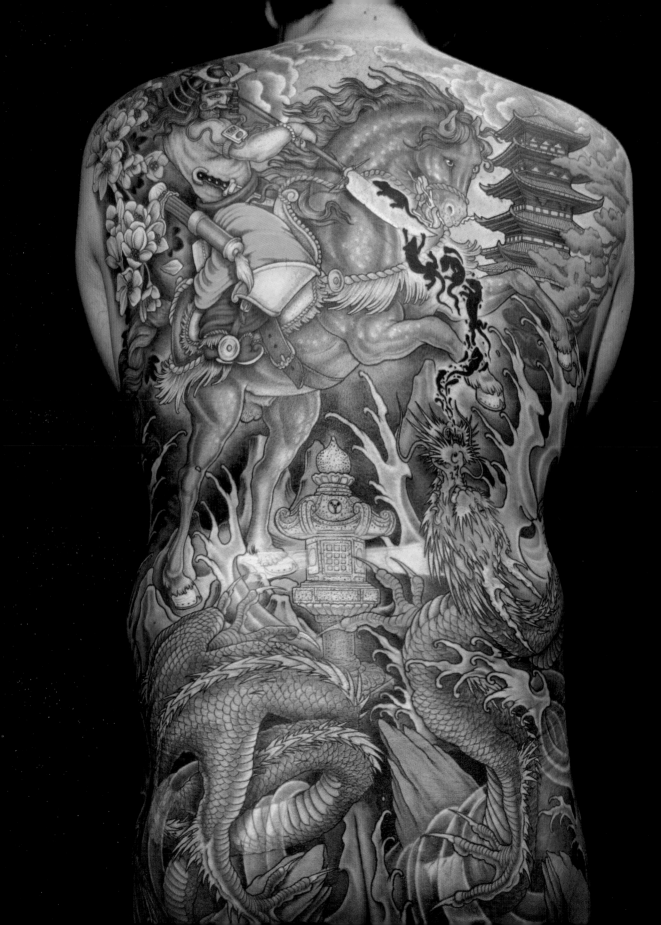

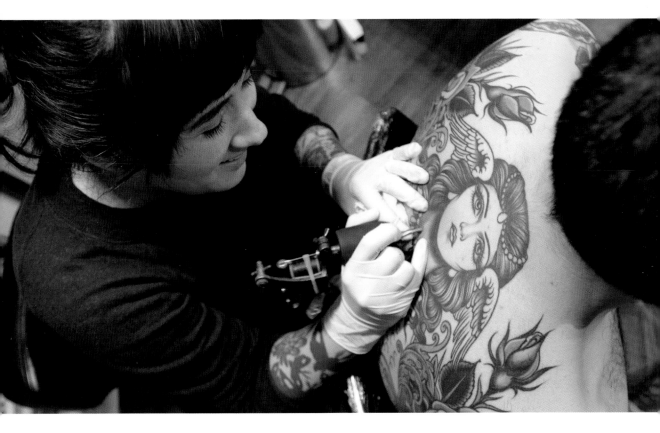

VALERIE VARGAS

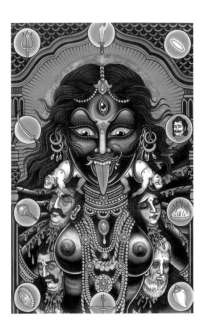

Valerie has been tattooing for 8 years, most recently with her husband Stewart Robson – they opened 'Modern Classic Tattoo' in Fulham, London where they both tattoo. For the first seven years of her career she worked at Dante Di Massa's internationally acclaimed Frith Street Tattoo in the heart of London's Soho area. Valerie credits Dante's with giving her 'the best opportunity of her life' and letting her find her way in the world of tattooing by being taken under his wing.

As well as working at the new studio Valerie can also be found working at many conventions. Famed for her beautiful, traditional colour work, she is also proficient in Japanese- and black-and-grey-style tattooing.

Valerie says the influences throughout her career have been varied but the most notable are Ed Hardy, Bob Roberts, Sailor Jerry, Scott Sylvia, Chris Conn, Jack Rudy, Chino, Tony Hundahl, Tim Lehi, Chris Garver . . . and many more!

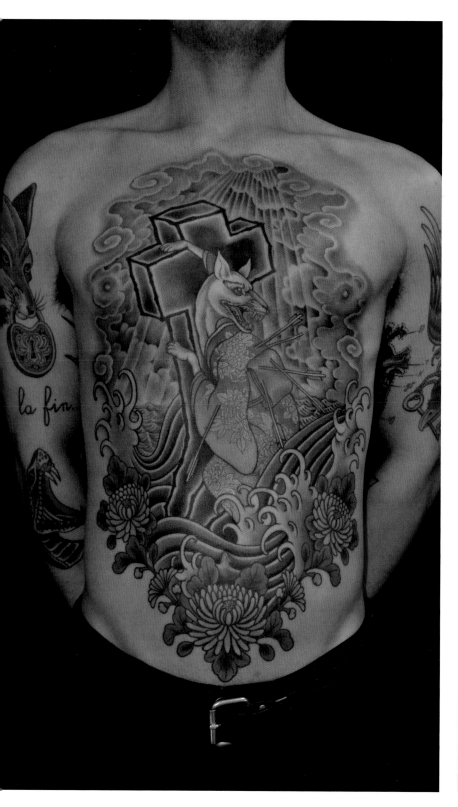
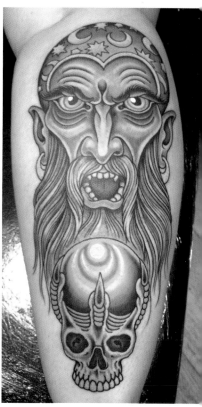
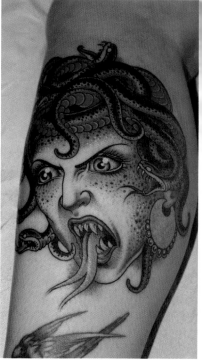

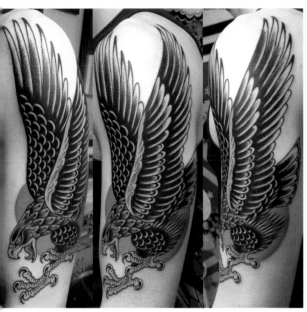

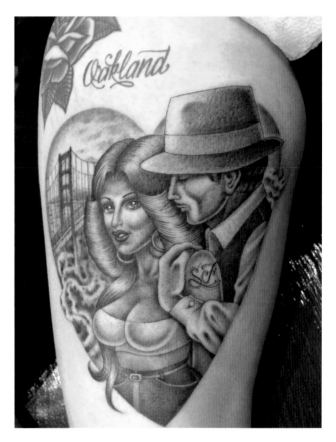

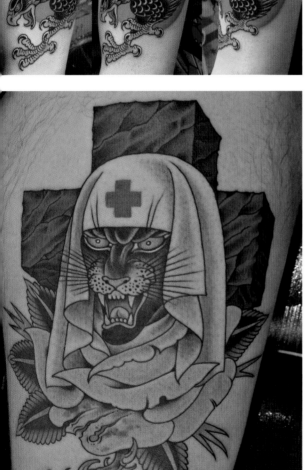

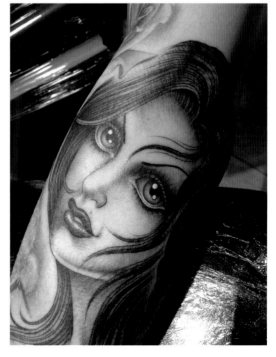

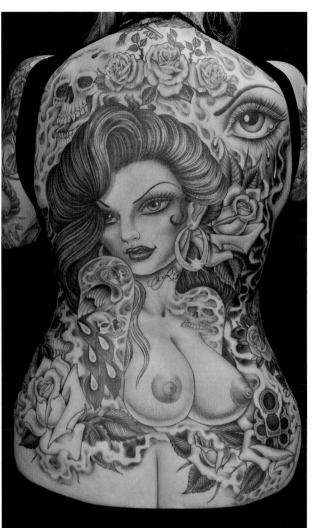

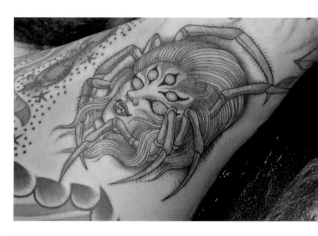

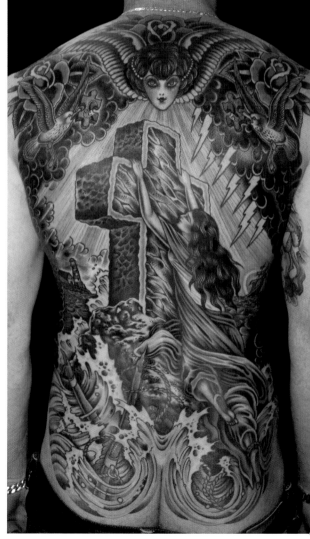

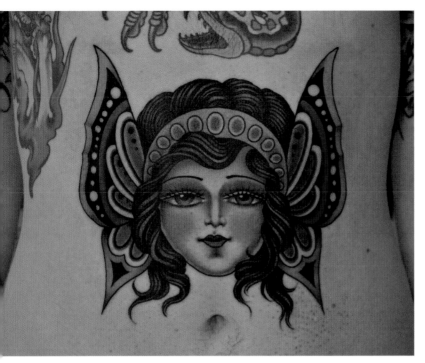

See more at
www.valerievargas.com,
www.modernclassictattooing.com

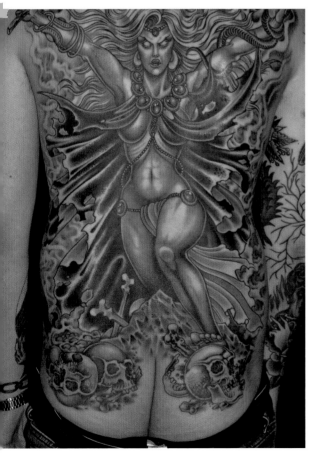

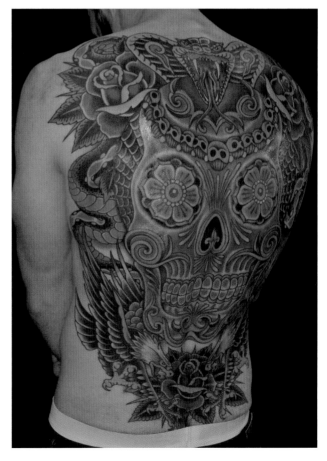

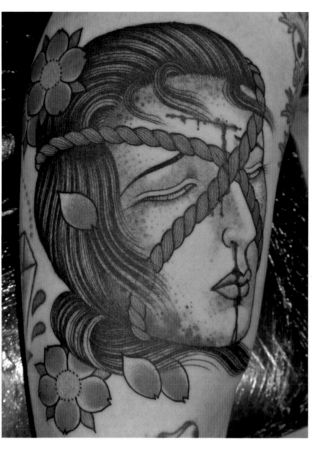

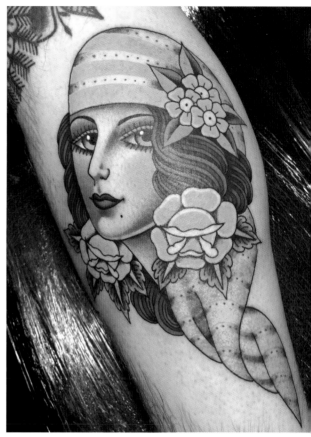

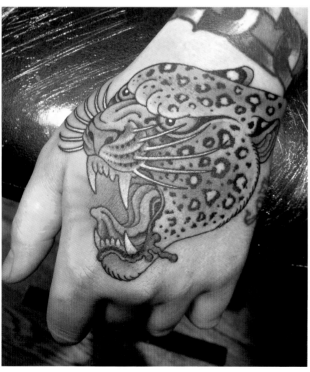

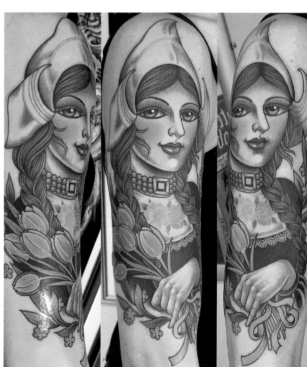

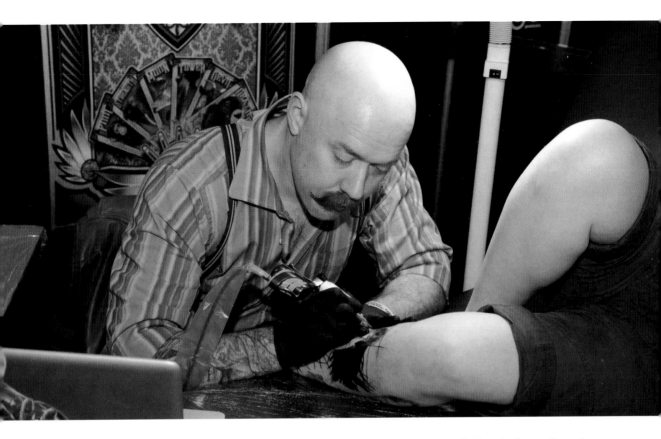

DAVID
CORDEN

David's grandparents in pencil

David grew up in Sittingbourne in Kent, in the south-east of England. There he studied art at Fulston Manor School, working towards an A level – which he failed. When questioned they stated that his work 'looked so much like a photo you may as well have handed in a photo'. He was given a 'U' grade, the lowest that can be given.

Undeterred, he went on to attend the Canterbury College of Art and Design. While he did gain a diploma in Graphic Design there, he knew this wasn't the career for him so started work as a ventilation engineer – a temporary job that lasted fifteen years. Throughout this time any thoughts of working as an artist left him. It was only while getting his first tattoo, a design of his own, that it all changed. His tattooist and future boss, Jim Gambell, saw potential in David and subsequently he started his tattooing career.

On his first visit to Edinburgh, David fell in love with the city, instantly making the decision that this was the place to open his studio. The studio, which is being designed with an opulent twist, is opening in June 2015 – the much-anticipated next chapter in his career.

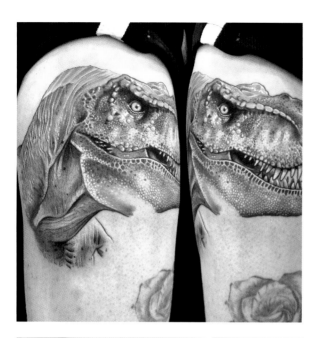

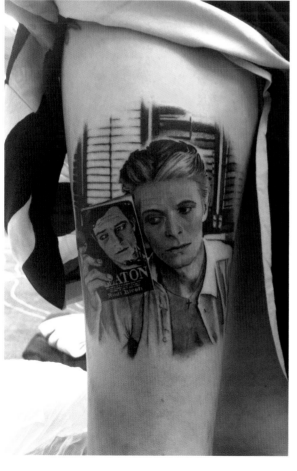

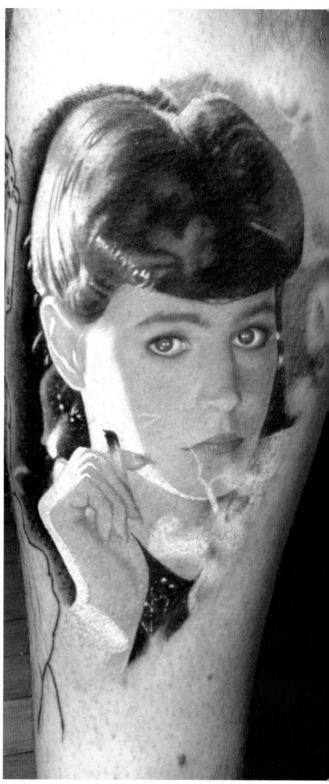

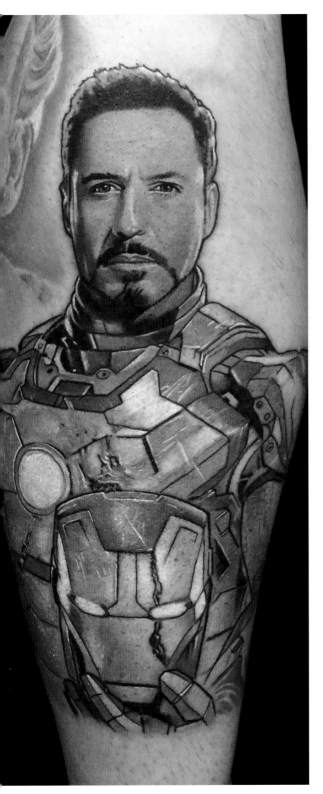

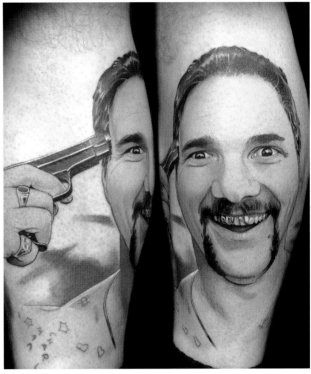

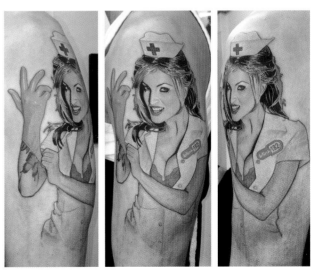

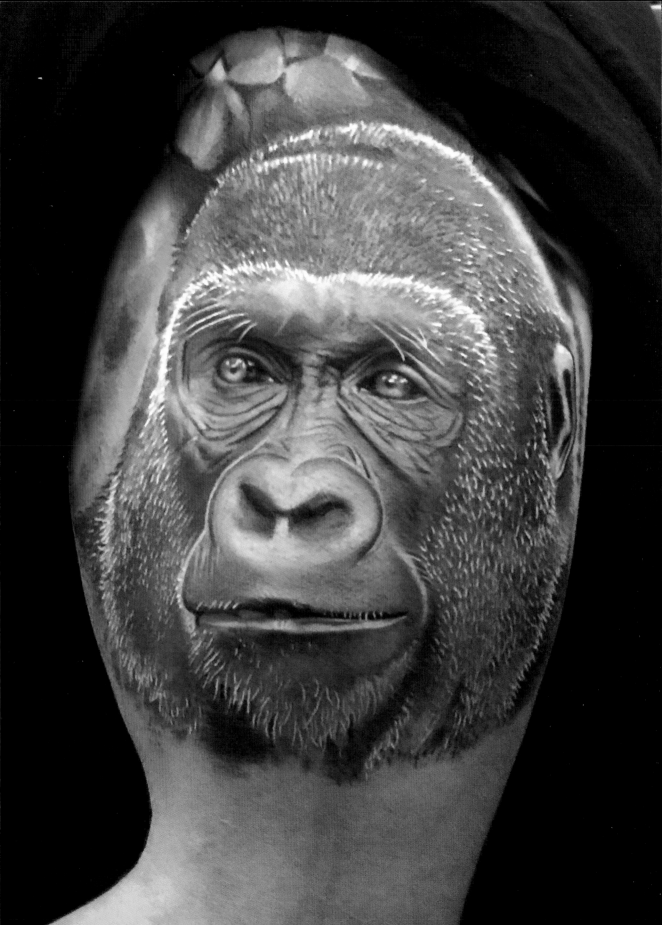

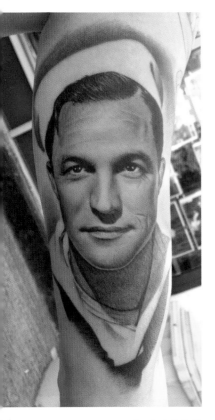
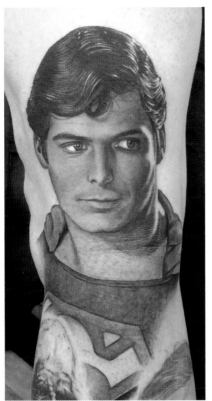
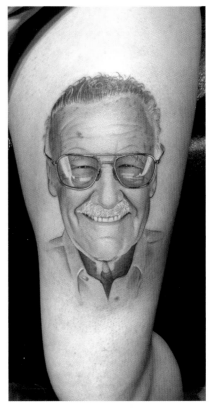
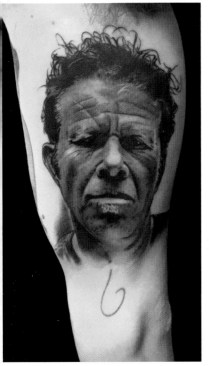
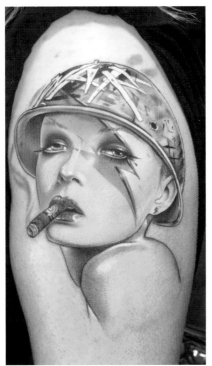
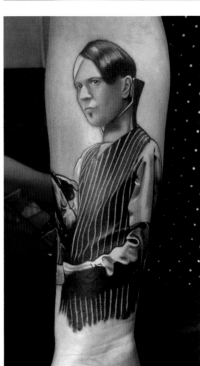

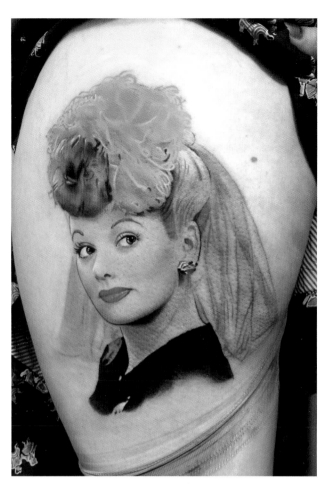

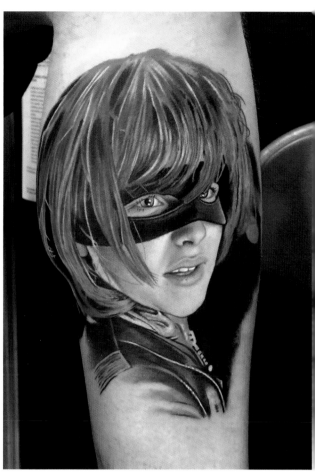

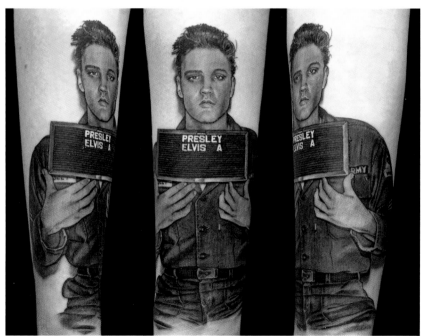

See more at
www.sempertattoo.com

BOB
TYRRELL

Born in Detroit in 1962 with an incredible artist for a father, Bob grew up wanting to be an artist himself. However, from his early teens he played guitar for various heavy-metal bands and worked in a factory, so it was some years before Bob actually went under a tattooist's needle. At the age of thirty he got his first piece and was soon hooked, getting sleeves and a full back piece. With his interest in art renewed he was soon drawing again. His work gained attention from Tramp at Eternal Tattoos in Detroit, he was offered an apprenticeship, and within three months he was tattooing full-time.

Bob is always quick to acknowledge that he is forever grateful to Tramp and to Tom Renshaw, who took him under his wing. After six years working at Eternal, Bob opened his own studio Night Gallery in Detroit. These days he is a regular at conventions worldwide and says he's 'livin' the dream'.

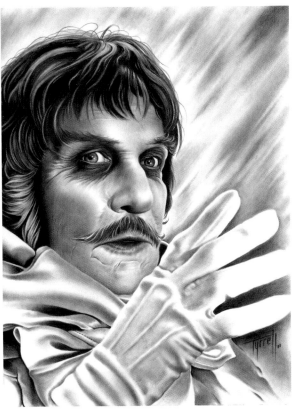

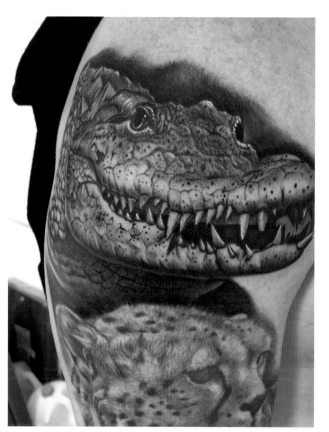

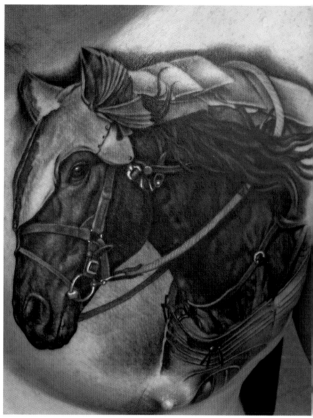

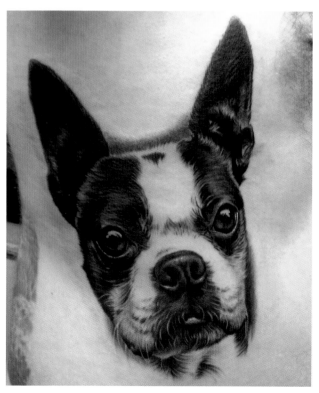

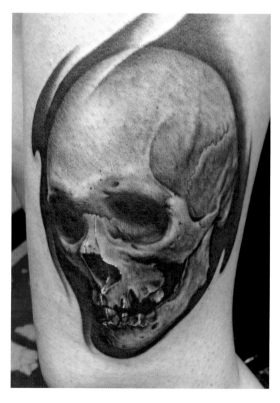

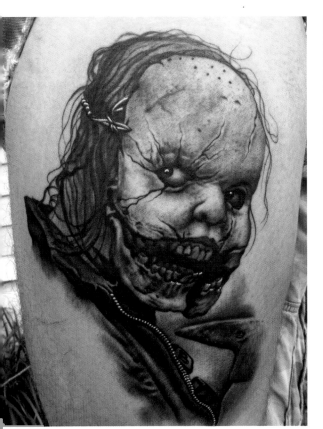

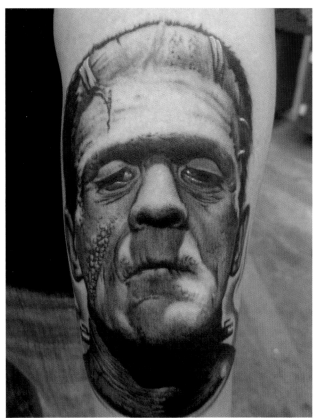

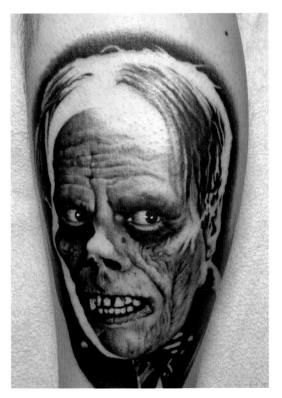

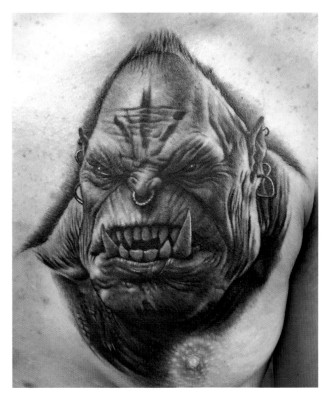

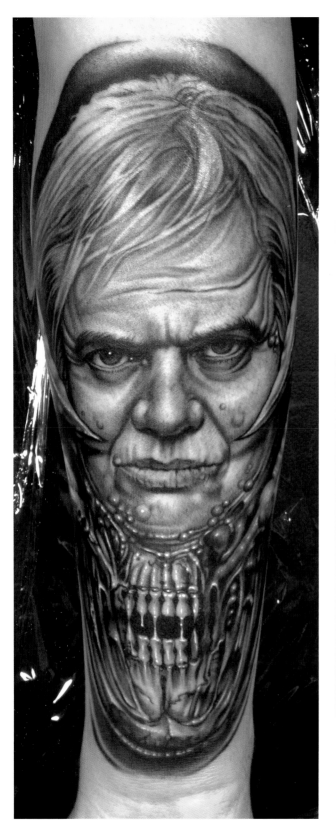

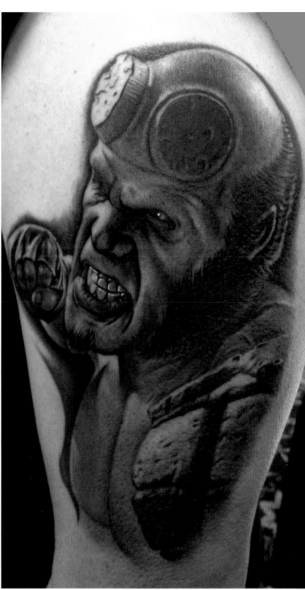

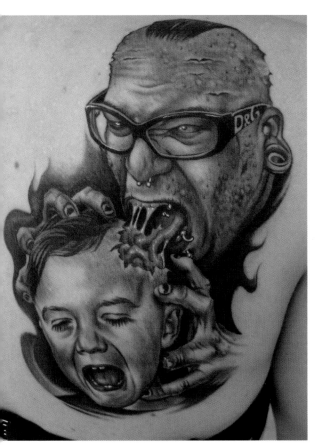

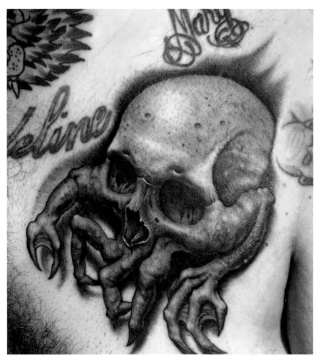

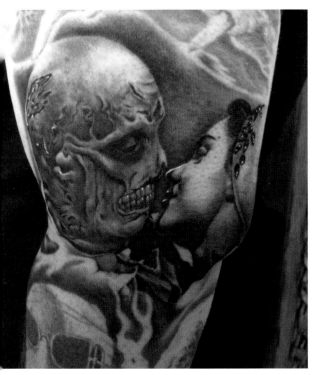

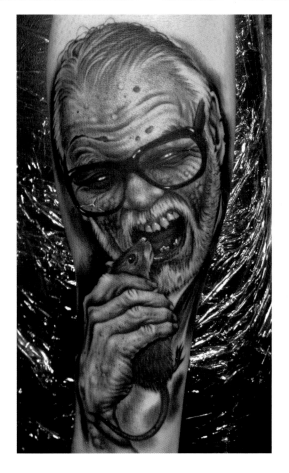

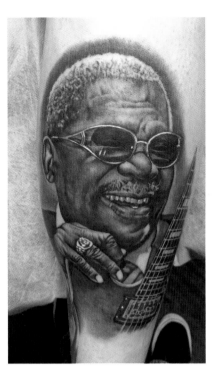
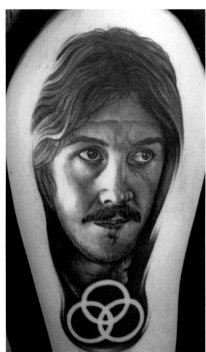
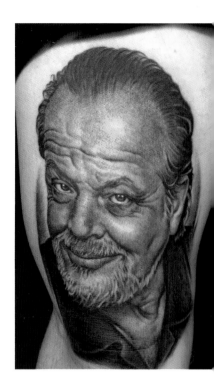

See more at www.bobtyrrell.com

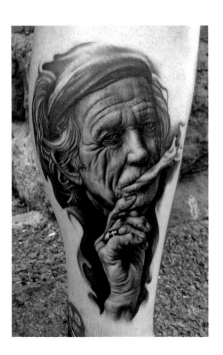
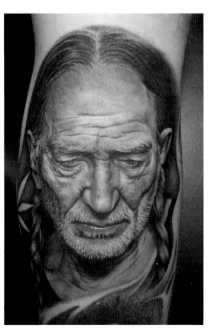
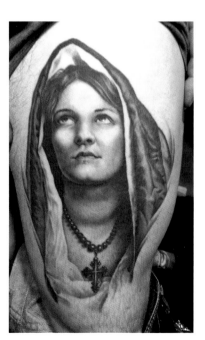

EMMA
KIERZEK

Emma, tattoo artist and studio owner at Aurora Tattoo in Lancaster, writes:

'My mum's a wonderful artist and a big inspiration to me. In some way or another art has been a constant passion throughout my life. At eighteen I decided to channel that into tattooing and naturally orientated toward realism and portraits. I love taking something that has had such an impact on someone and being able to capture it and put it into their skin, into their life.

Always searching for new ways to capture the feelings of a picture, the material within it, I want things to look like they feel to touch them. After sixteen years I'm still pushing, searching and striving for IT.'

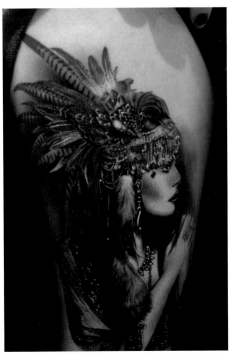

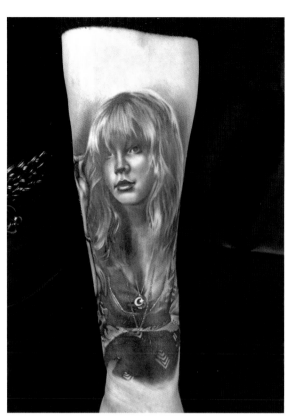

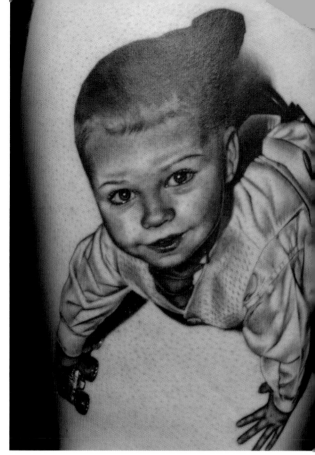

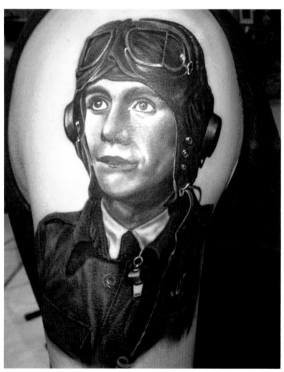

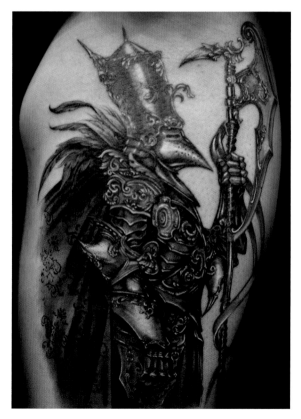

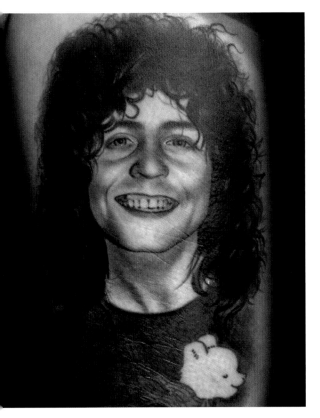

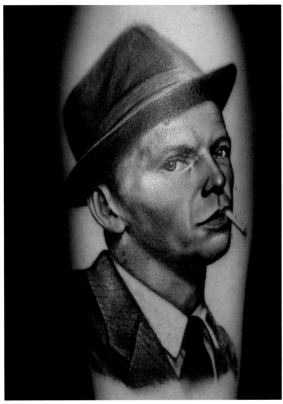

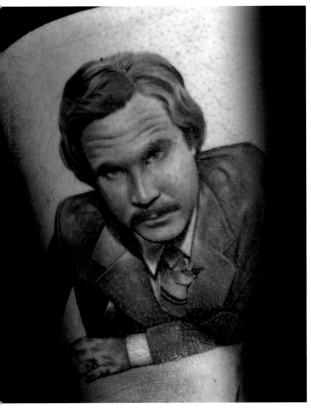

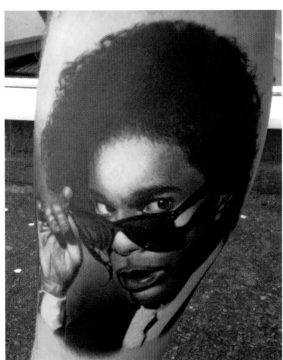

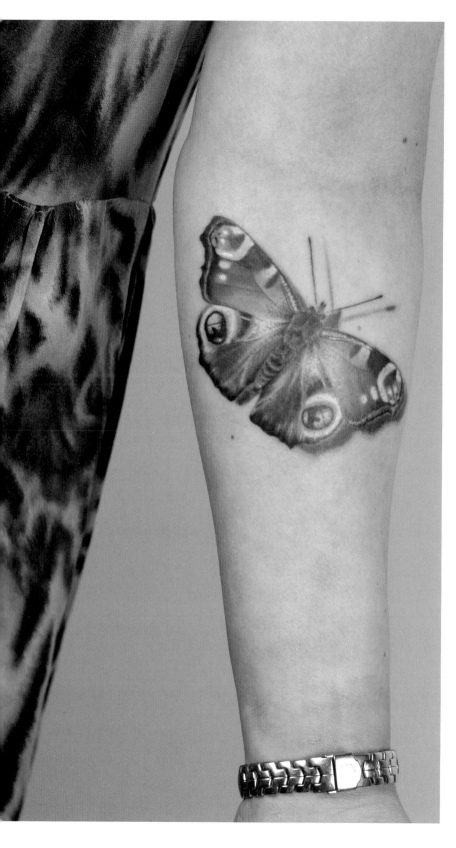

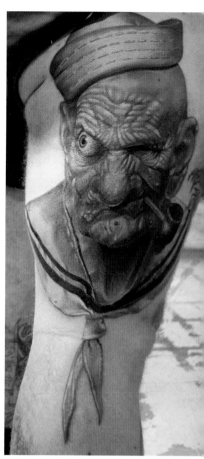

See more at
www.auroratattoostudio.co.uk

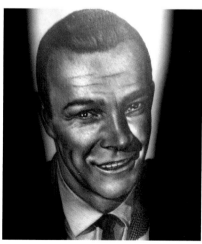

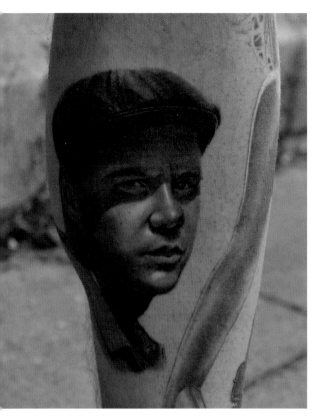

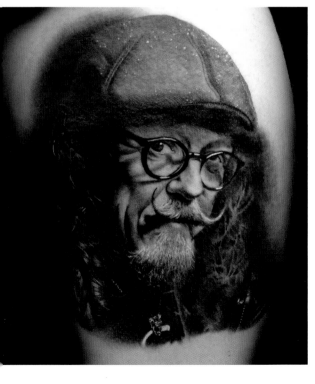

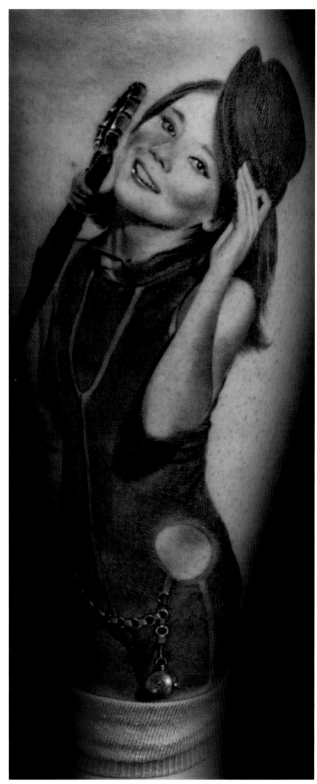

DAN SMITH

Born in England and raised in New Zealand, Dan Smith has chosen Southern California as the place he calls home. He originally moved to Orange County in 2004 after years of extensive travel throughout the U.S. and abroad, pursuing both music and tattooing. In 2008 he began working in Hollywood at Kat Von D's High Voltage Tattoo. In 2009 he joined the cast of TLC's *LA Ink*, and was a featured cast member throughout the third and fourth seasons of the program. After the conclusion of the show in 2011, Dan continued tattooing in Los Angeles until the end of 2012, while maintaining a heavy travel and touring schedule. Then, in 2013, he left High Voltage to establish his own Captured Tattoo in scenic Old Town Tustin in Orange County, California.

Dan is an accomplished, all-rounded tattooer who is mostly recognized for his bold, detailed and colourful work. His influences range from album art and logos to '80s skateboard graphics and culture but his admiration for classic traditional imagery always shines through brightly.

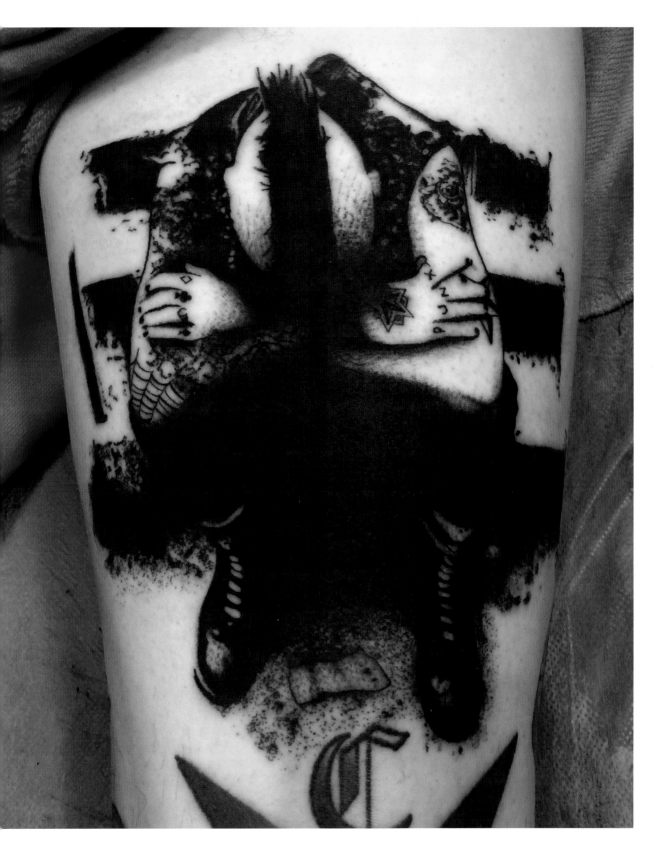

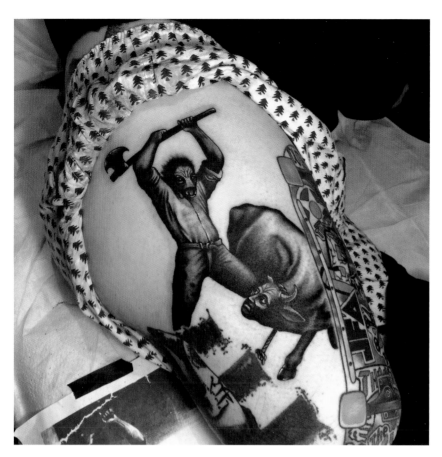

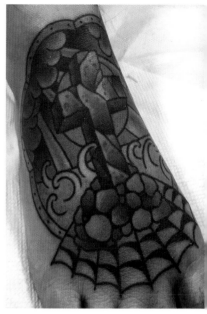

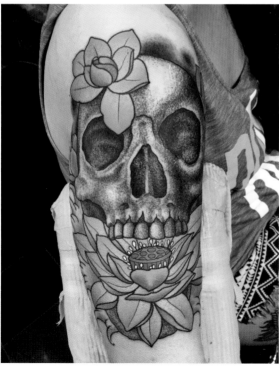

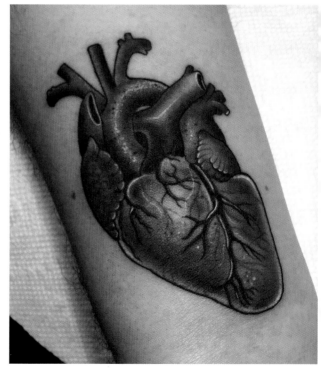

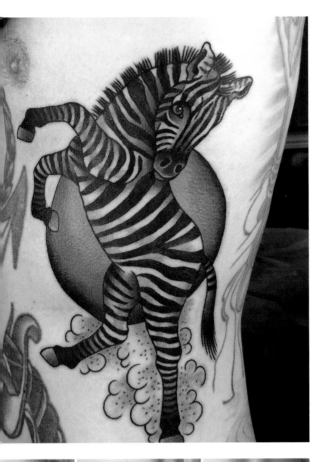

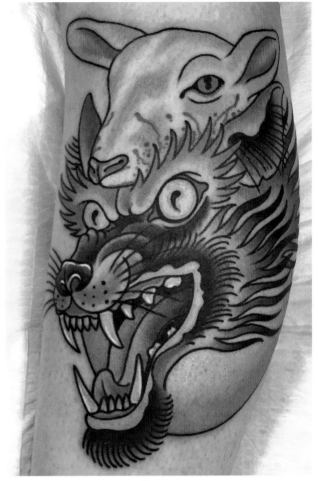

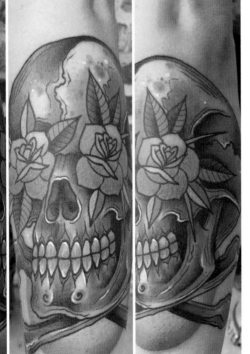

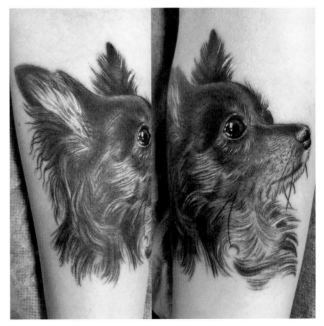

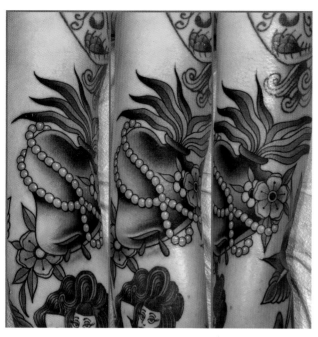

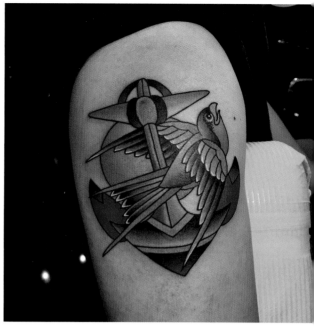

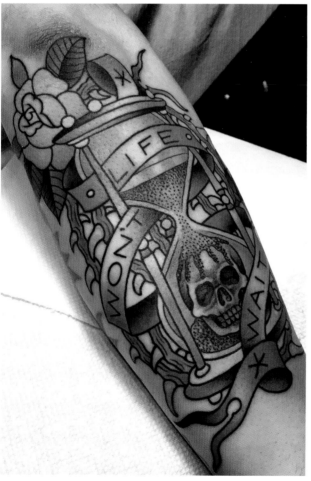

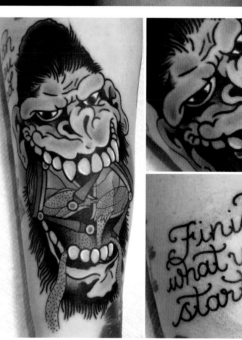

See more at www.capturedtattoo.com

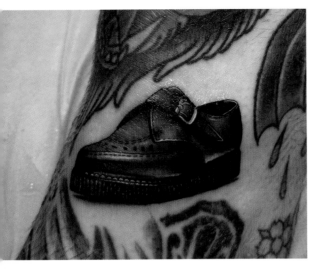

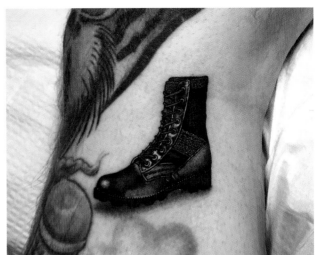

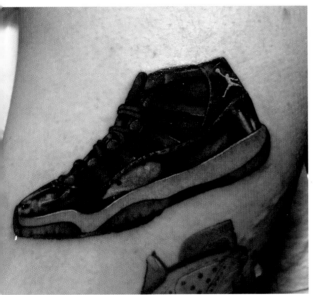

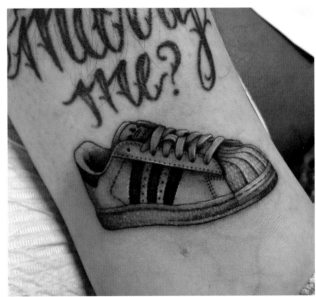

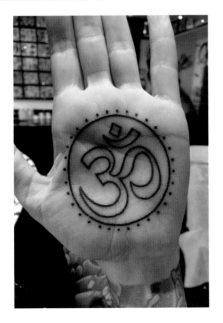

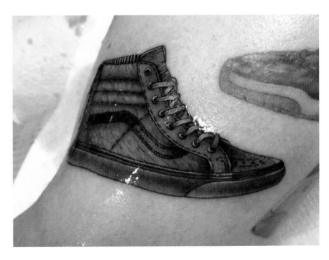

FILIP LEU

'Tattooing for thirty-four years . . .
"there is no way to happiness,
happiness is the way" – The Buddha.'

Filip Leu

Filip Leu is without doubt one of the most influential tattoo artists the world has ever known. The son of Felix and Loretta Leu, two respected tattooists and artists in their own right, and also great travellers, Filip began to learn the skills of tattooing from his parents at the age of eleven while in Goa, India. By the time he was fifteen, he had created, along with his parents, the now legendary Leu's Family Iron Studio in Lausanne, Switzerland, a mecca for tattoo artists and clients alike. Filip further honed his tattooing skills while working around the globe with some of the luminaries of the tattoo world.

Famed for his large-scale, Japanese-inspired body suits, his enthusiasm for art and tattooing is infectious. Filip's style is constantly evolving and he continues to create visionary, mind-blowing tattoo works on an epic scale.

Opposite: Artwork by Filip

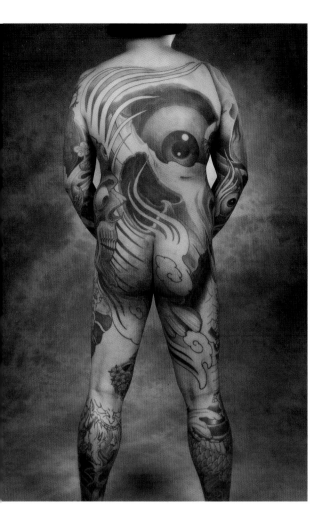

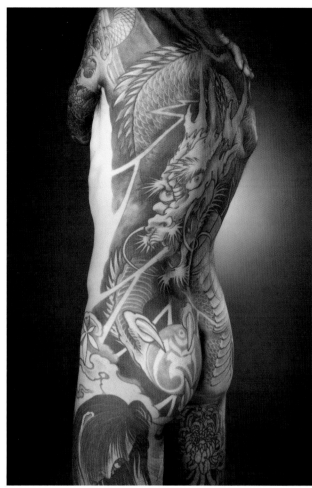

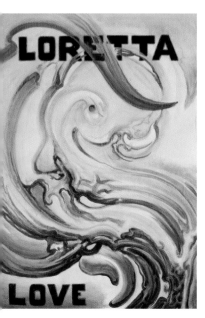

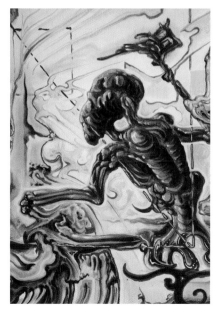

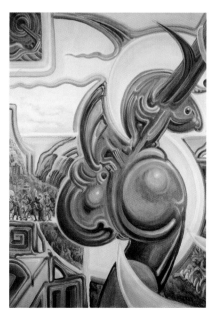

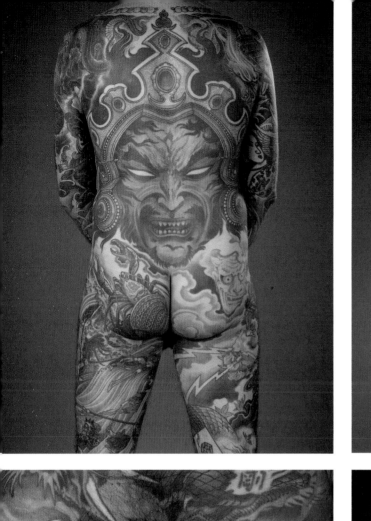
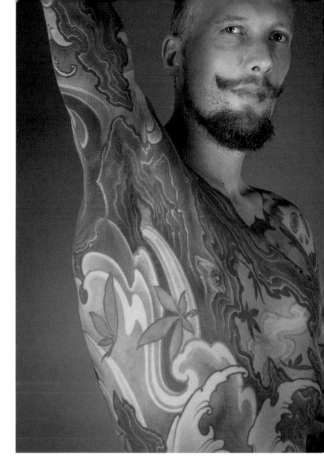
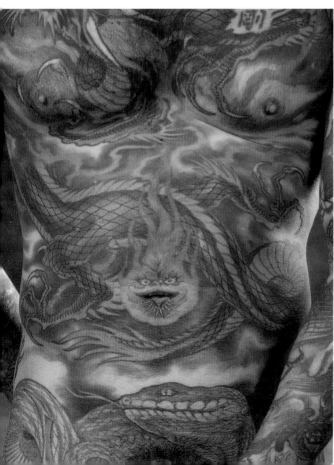
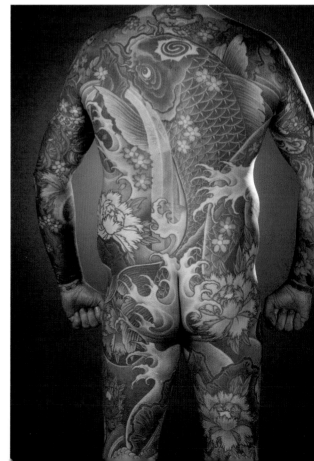

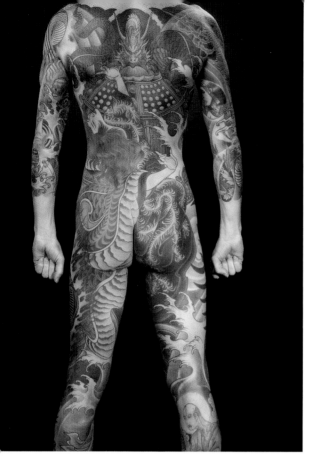
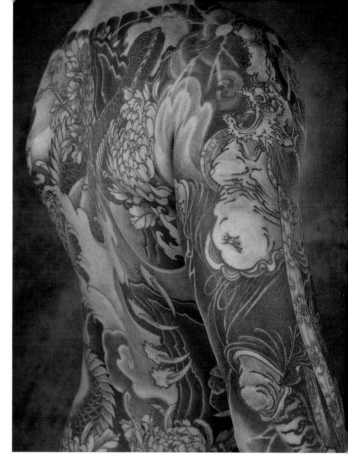
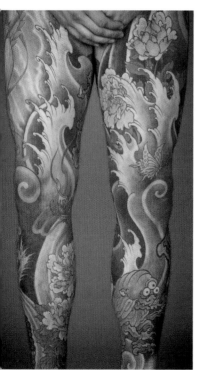
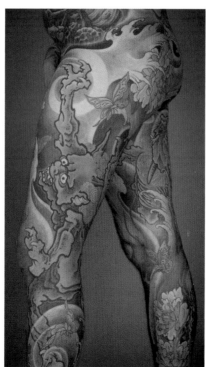
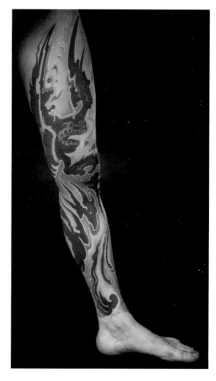

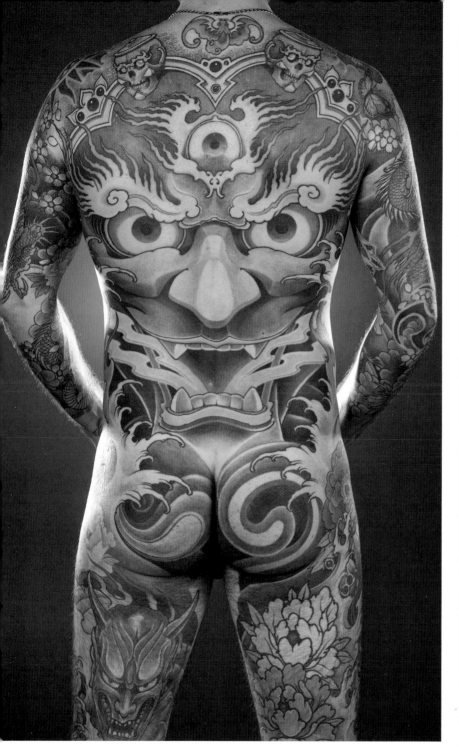
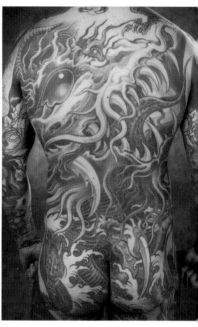
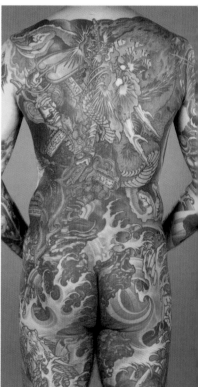

See more at www.leufamilyiron.com

PAUL
BOOTH

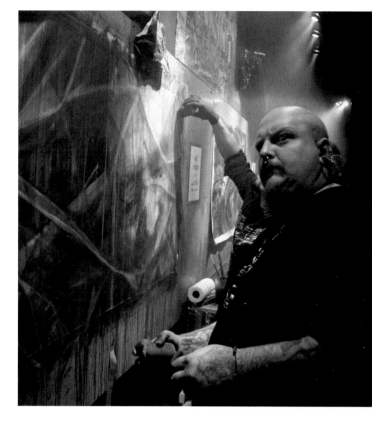

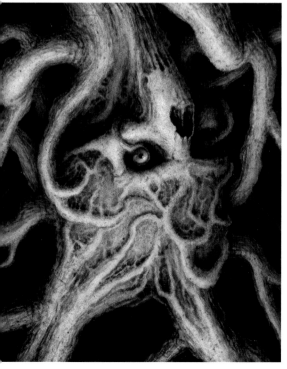

Having been tattooing for over twenty-five years, Paul Booth's style is instantly recognizable – a master of the dark demonic horror genre, his work draws an audience from every corner of the globe. With a celebrity clientele including Slipknot, Fred Durst, Slayer and Pantera, *Rolling Stone* magazine described him as 'The New King Of Rock Tattoos', a fitting title indeed.

In 2007, Paul opened what I can only describe as the most amazing tattoo studio I have ever visited: Last Rites Tattoo Theatre in New York. A mixture of art gallery, cinema and tattoo studio on a horror theme of epic scale, all created through his visionary eye. Painting and sculpture are also media in which Paul creates his macabre, dark imagery and his work is now much sought after, not just by tattoo fans, but in the art world in general.

Paul has a crew of amazingly talented artists working at his studio – it truly is an incredible place to visit and get tattooed.

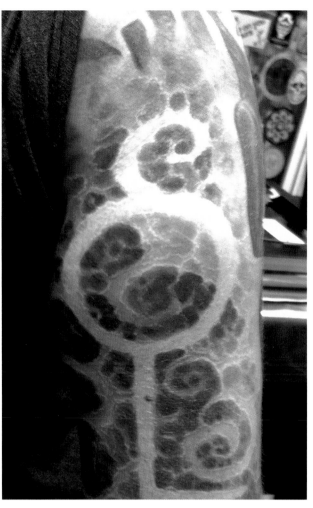

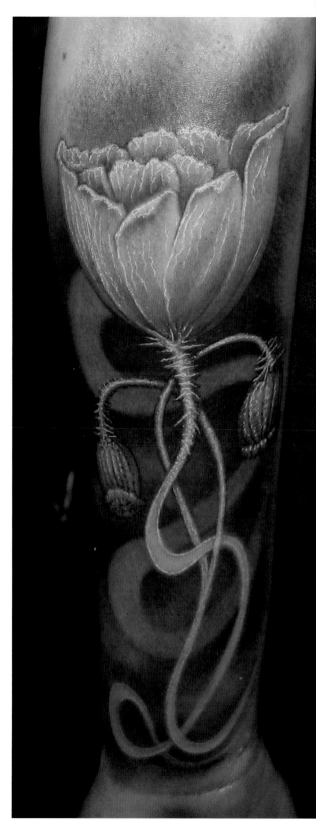

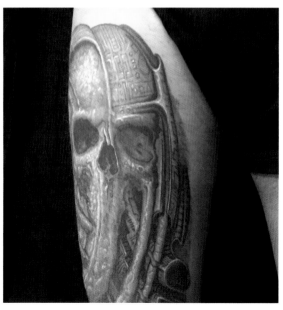

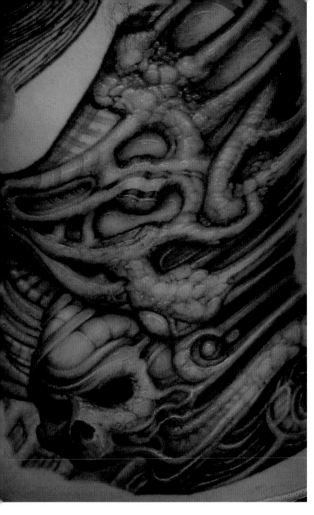

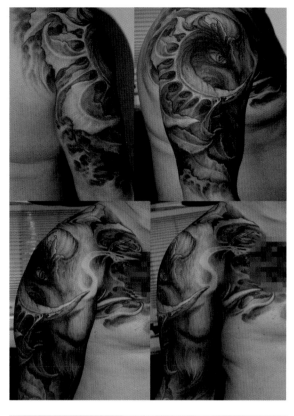

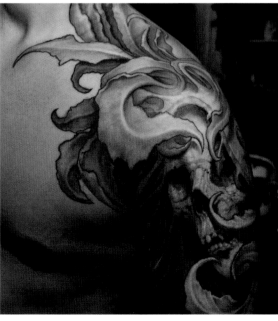

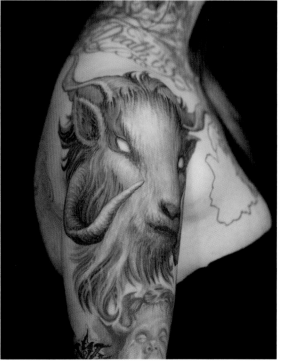

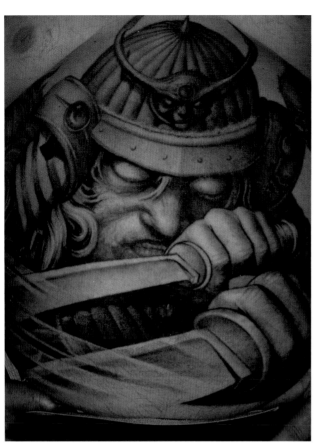

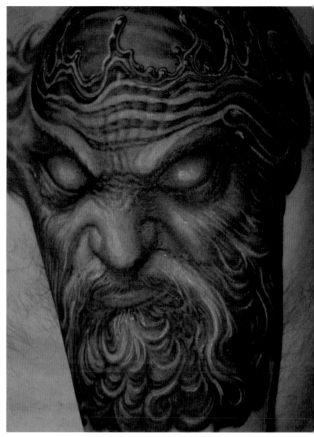

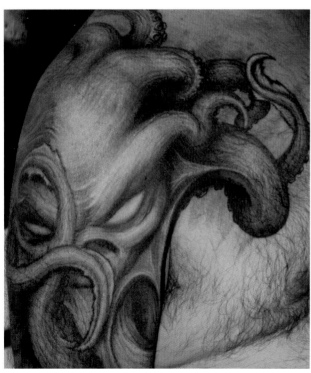

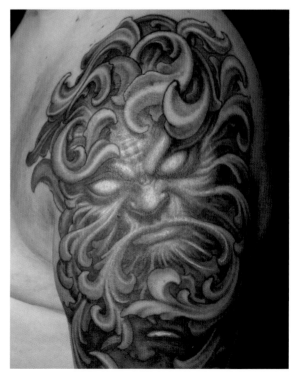

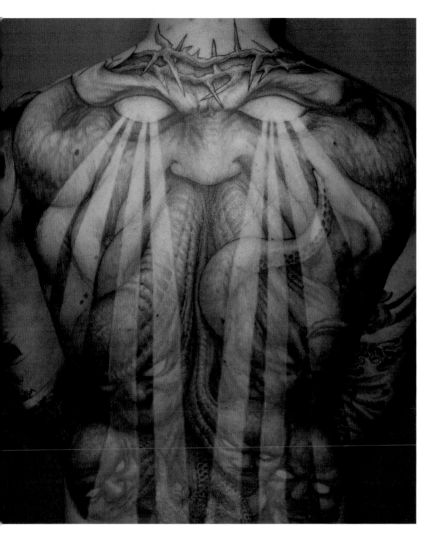

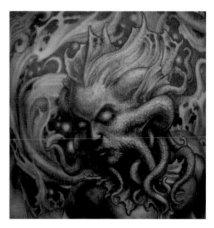

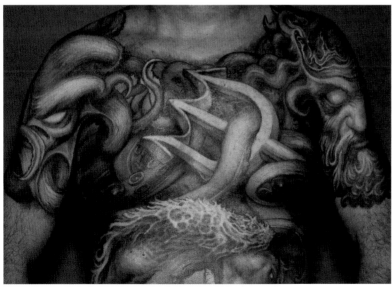

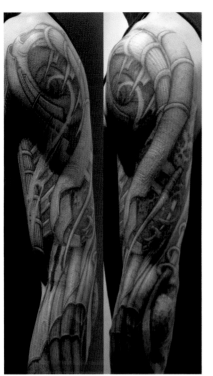

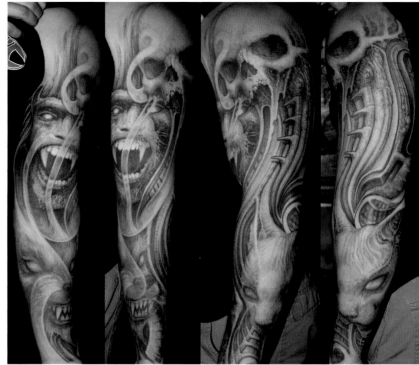

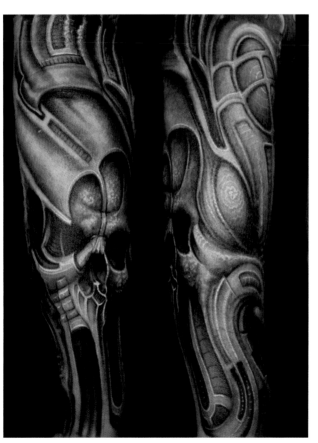

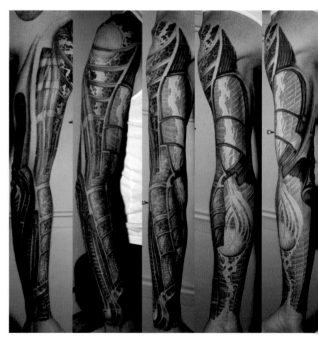

See more at www.lastrites.tv

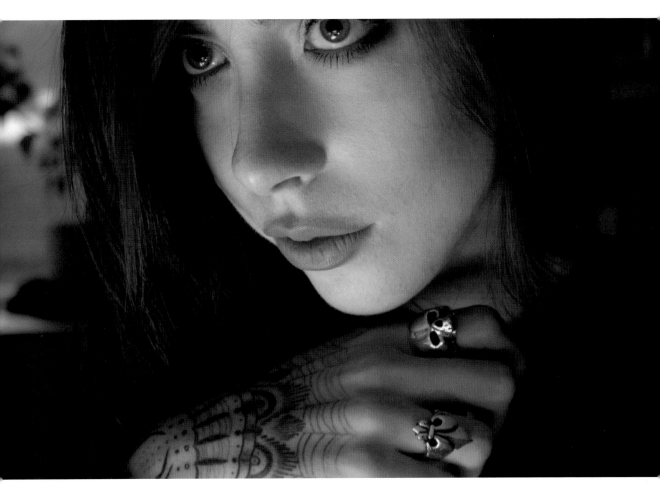

AIMEE CORNWELL

It is fair to say that, as the daughter of London tattooer Mark Cornwell, the art of tattoo is in Aimee's blood. Her early works were in a more traditional tattoo style but her 'fantasia' style is distinctively her own. Working mainly freehand, her beautiful depictions of animals, flowers and female faces have gained her a massive audience in both the art and tattoo world.

When not working at conventions, Aimee can be found working at Nemesis Tattoo in County Durham with her partner John Anderton.

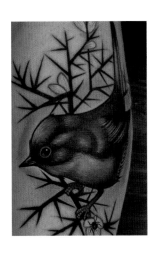

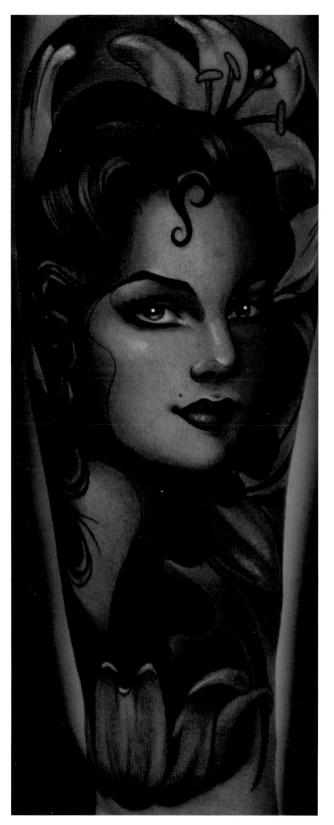

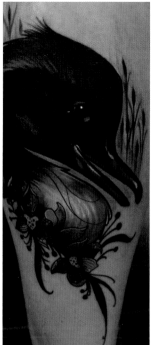

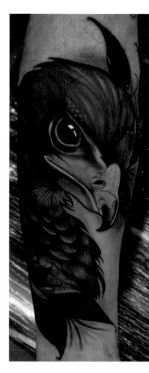

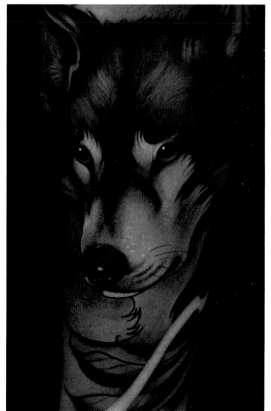

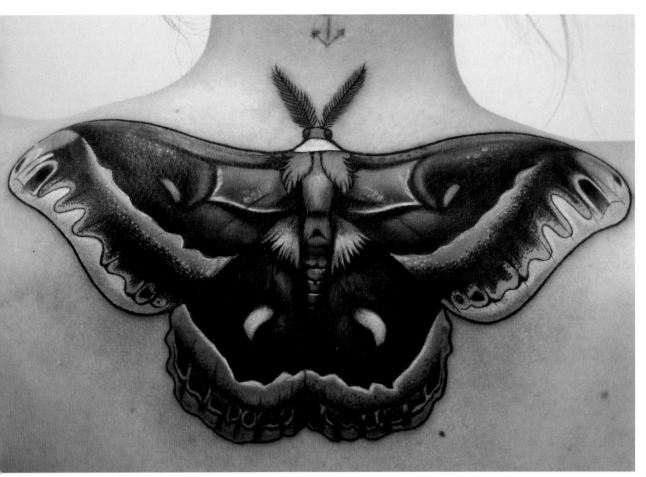

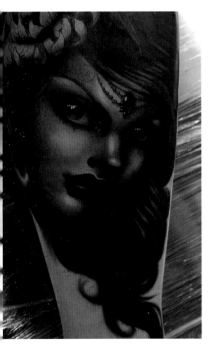

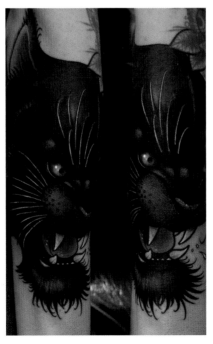

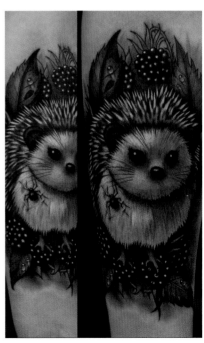

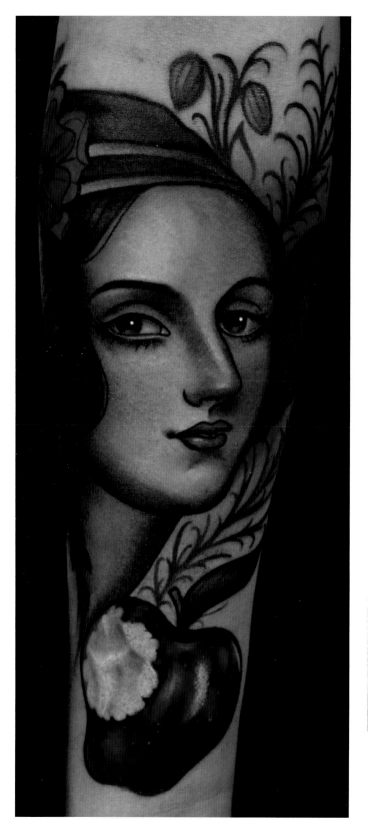

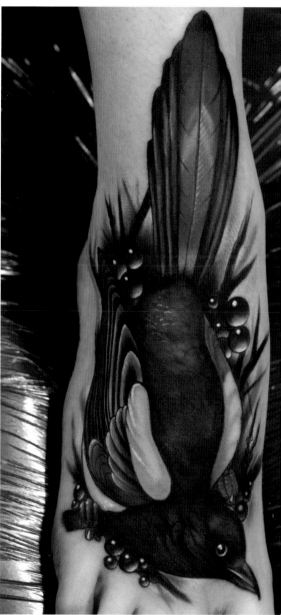

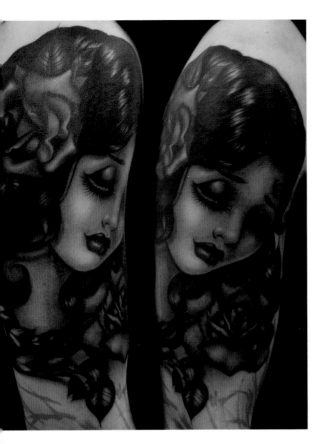

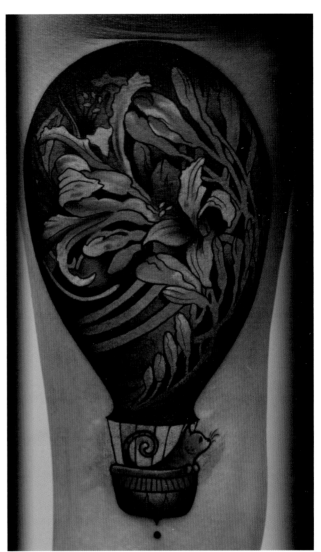

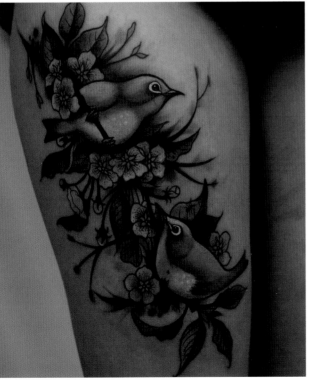

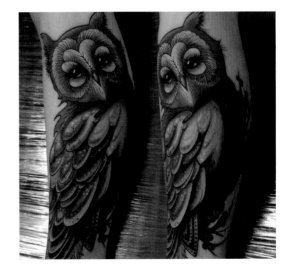

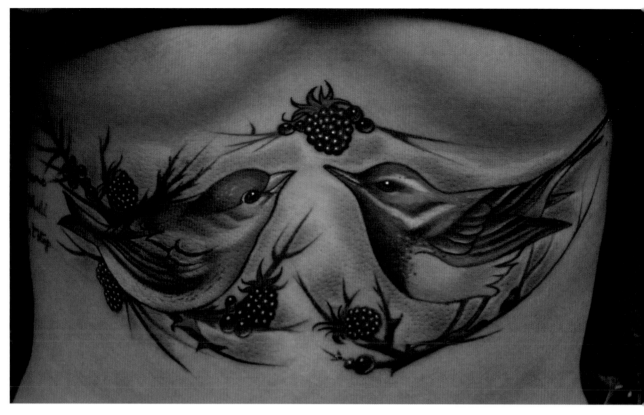

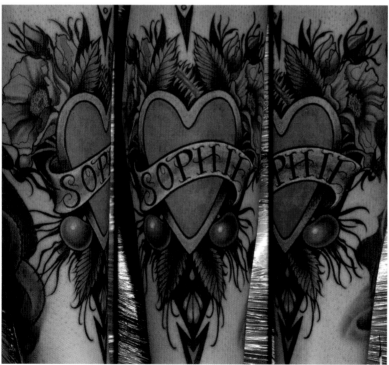

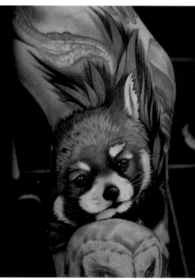

See more at
www.nemesistattoo.co.uk

RYAN
EVANS

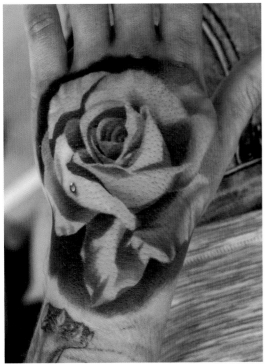

Originally from Whangarei in New Zealand, Ryan Evans is an artist who has taken the tattoo world by storm with his colour realism and his beautiful black and grey-style work with its super smooth tones and graduations.

Having served a traditional apprenticeship, Ryan soon established himself as a specialist artist in the realism field of tattoo art. At present he is travelling the globe tattooing at numerous conventions and tattoo studios as a guest artist.

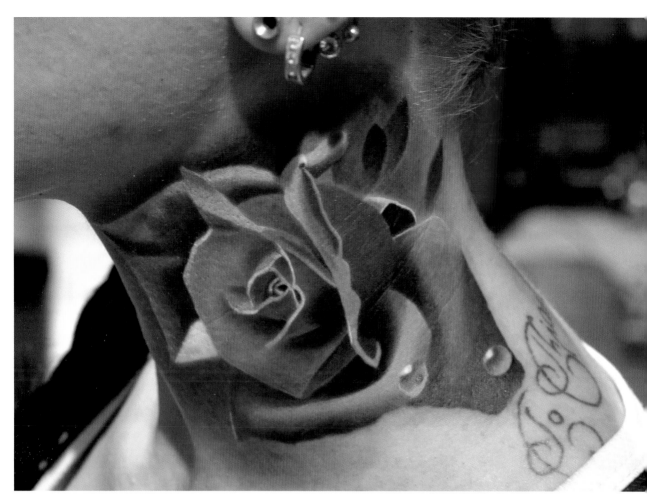

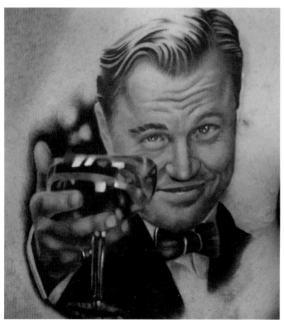

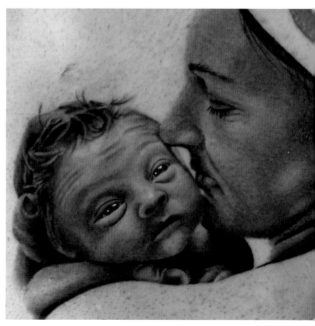

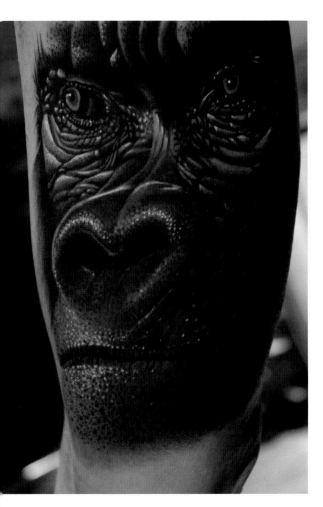

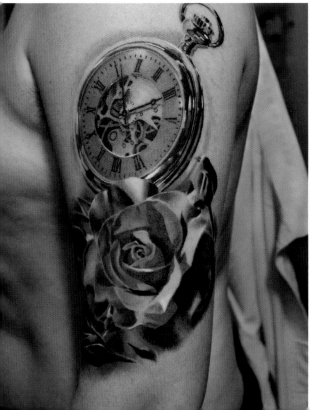

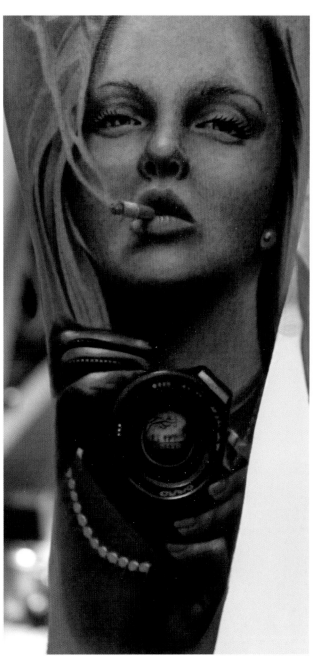

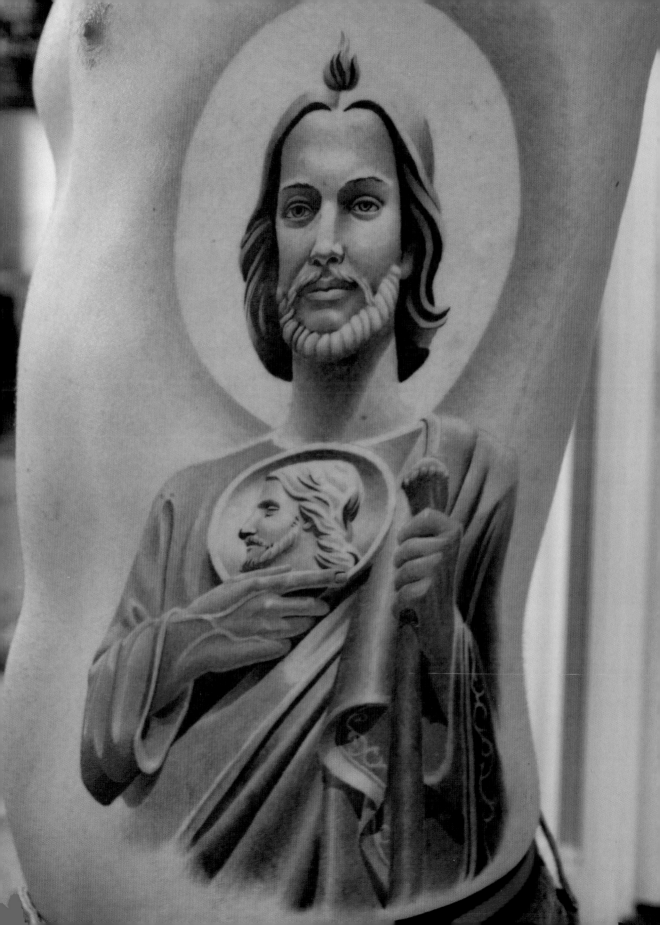

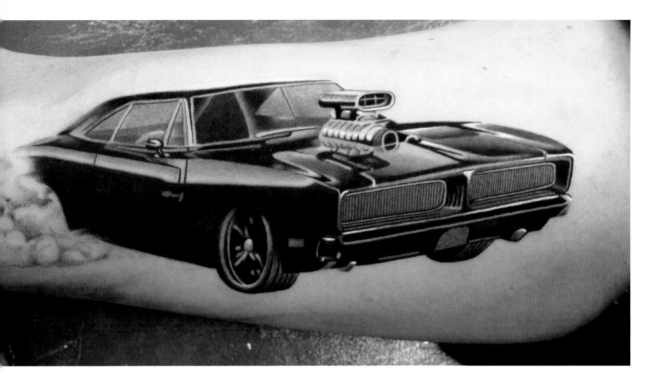

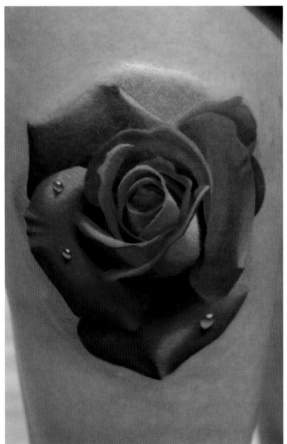

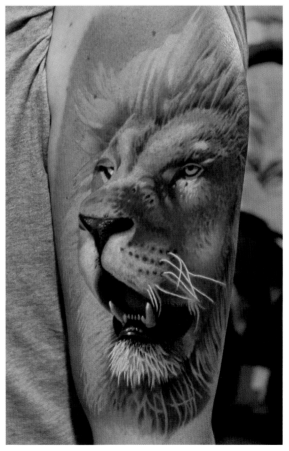

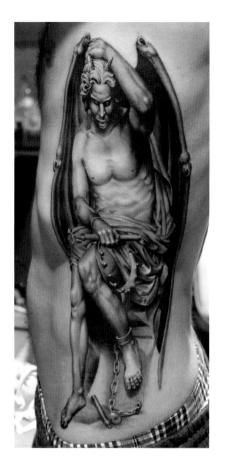

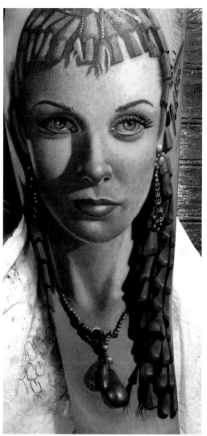

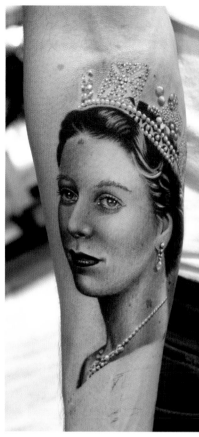

See more at www.facebook.com/
ryanevanstattoo

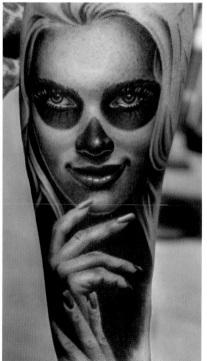

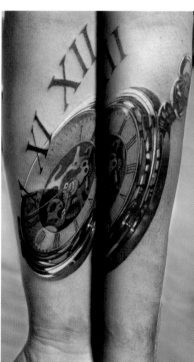

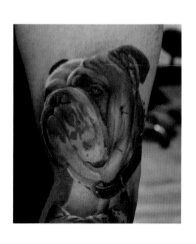

SILVIA ZED

I come from a small town in the north of Italy.
Tattoos were a rare sight, but my infatuation with
them began at just six years old. On a beach
holiday, I glimpsed a mother walking around with
her children and two full sleeves of tattoos, and
an old man with faded traditional work all over his
body. It was a huge revelation! I began to see these
people as fascinating individuals with a life's rich
history told in tattoos, and I thought, 'One day I
want to be like them!'

I moved to London in 1997 without any formal
art education. A year later, I met Alex Dudouet,
a traveling tattoo artist, while traveling in Mexico.
To this day he is my biggest influence, telling me
incredible tales about talented artists such as Filip
Leu and the Family Iron, and other amazing artists
and styles, too numerous to mention. My very first
tattoo was on Alex: after that, I was hooked!

I owe endless thanks to three truly inspirational
people: the amazing Xed le Head; Philip Milic,
owner of Old Crow Tattoo in Oakland; and
especially the legendary Lal Hardy. I was blessed
to be able to work with him for nine years and also
with highly influential artists like Bob Tyrrell and Paul
Booth – masters of black and grey. I developed
a style combing vivid realism and portraiture with
gothic imagery & smoky Victoriana, striving for a
smooth charcoal effect without too much pigment
grey, and to keep it looking classic and vintage.

Working with Lal taught me so much. He retains
effortless enthusiasm for the industry that hasn't
dulled or became jaded with time, I love him dearly,
and thank him for all those sweet hard times! My
own shop, Shall Adore Tattoo, which opened in
February 2013 in Shoreditch, East London, marks
the beginning of another story that keeps growing
in length, and more deeply reinforces all I have said
above, each and every day.

Silvia Zed

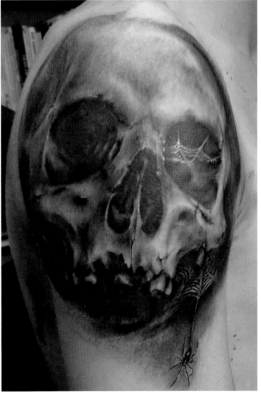

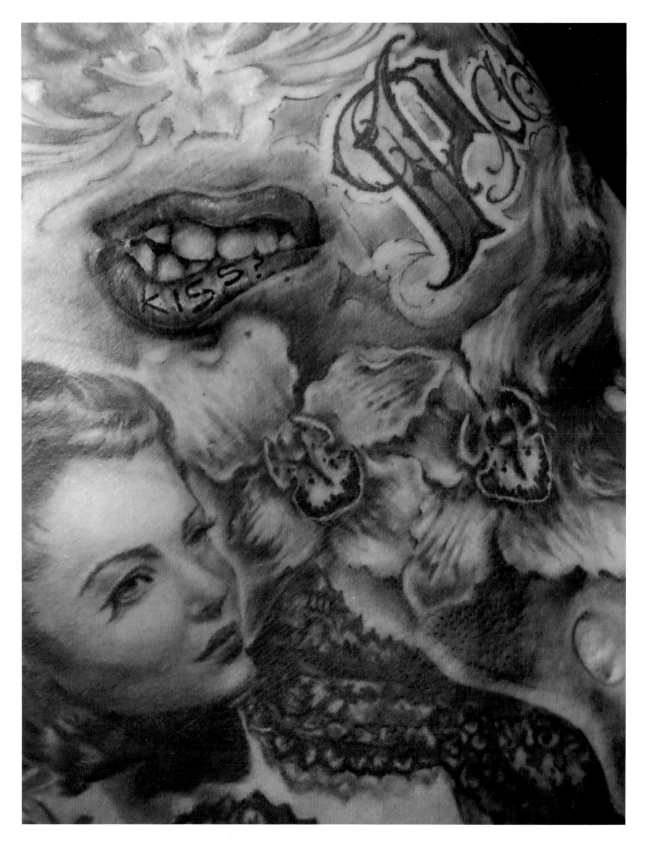

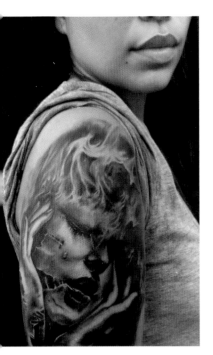
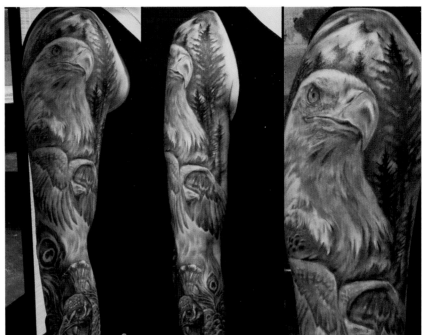
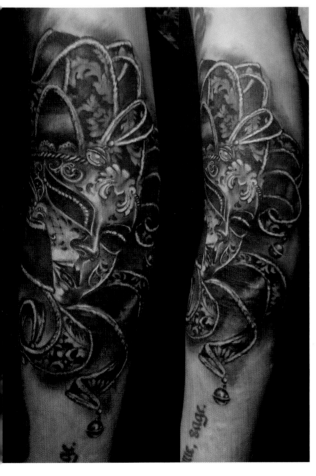
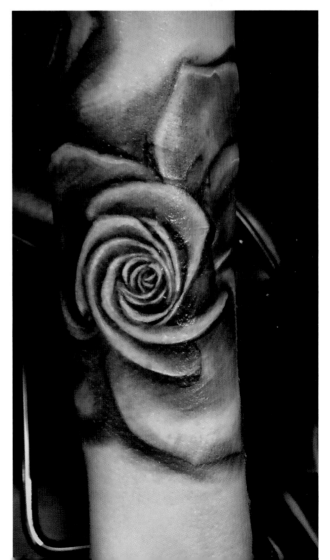

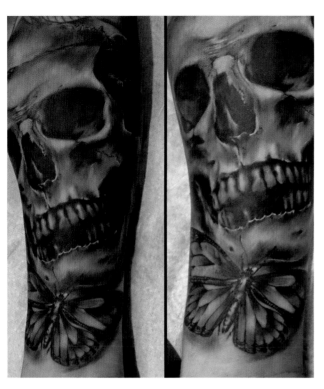

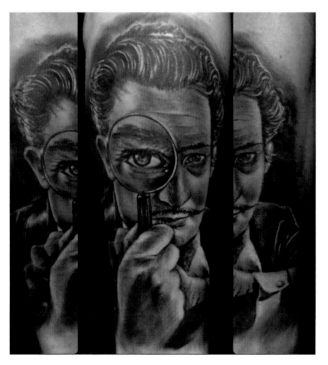

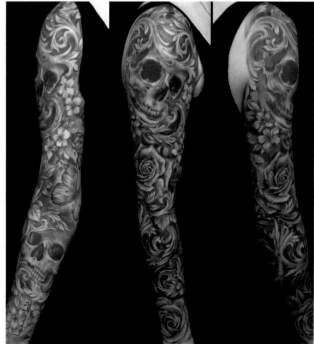

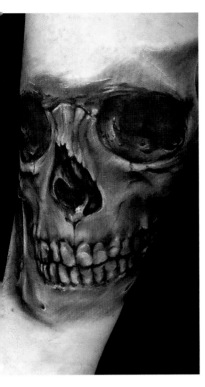
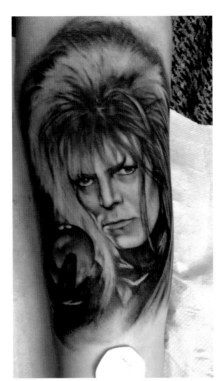
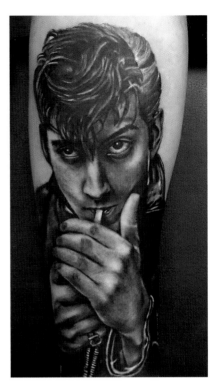
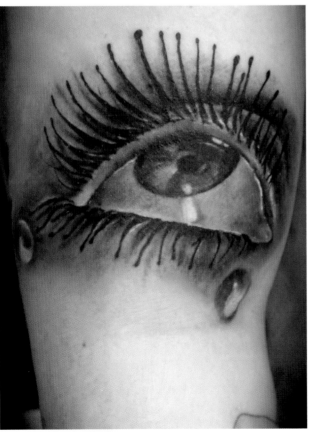
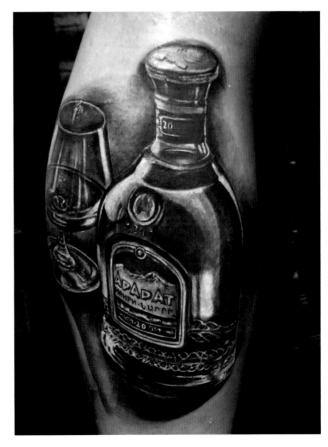

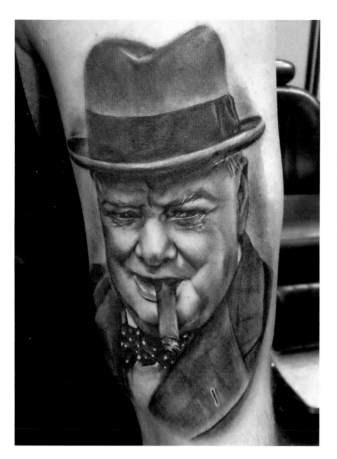

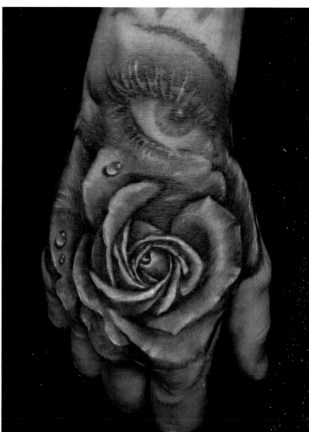

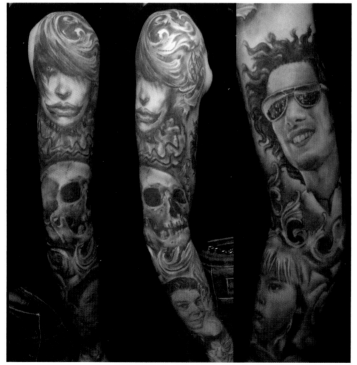

See more at www.shalladoretattoo.com

RHYS GORDON

After getting his first tattoo at the tender age of fifteen, Melbourne-born artist Rhys Gordon was bitten by the tattoo bug, and had completed his first tattoo by the following year! He has established a reputation for his large Japanese-influenced work, but he cut his teeth in the trade doing walk-ins and tattoo flash.

While travelling the world, Rhys has worked in more than thirty studios, the first of which was Tattoo Charlie's in Reservoir, Australia. Working in so many studios has provided him with a wealth of experience. He cites some of the biggest influences on his tattooing as being Kenny Mac, Trevor McStay, Cliffe Clayton and Tatudharma. Rhys still loves the trade after twenty-five years and his studio Little Tokyo keeps him constantly busy as he continues to create incredible large-scale tattoos.

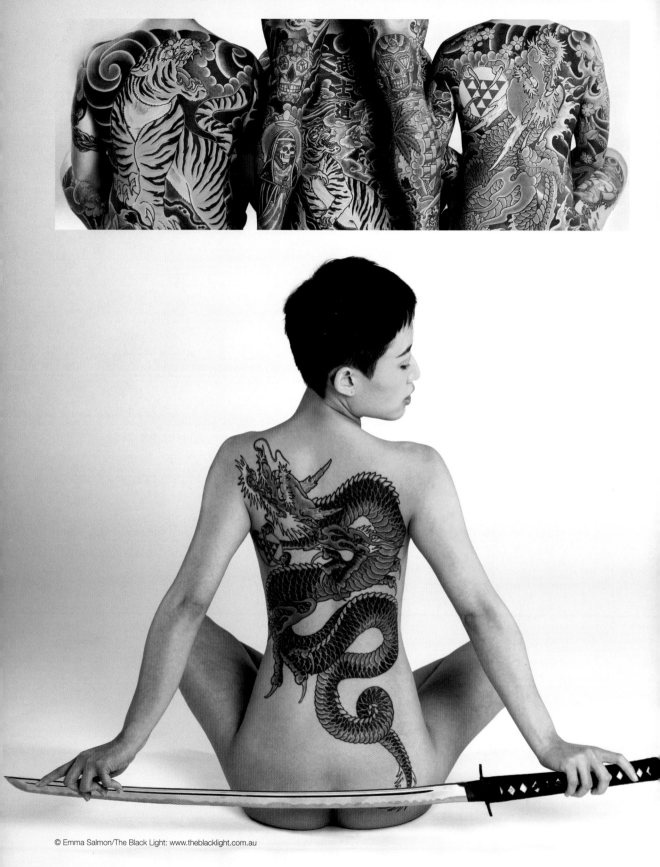

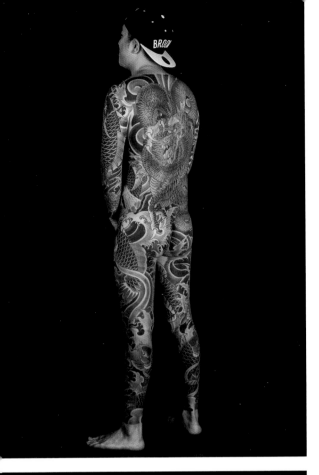

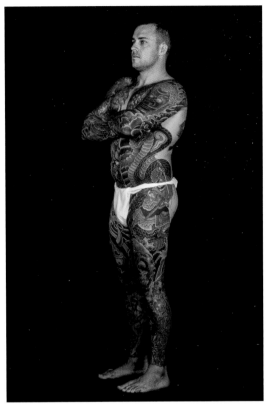

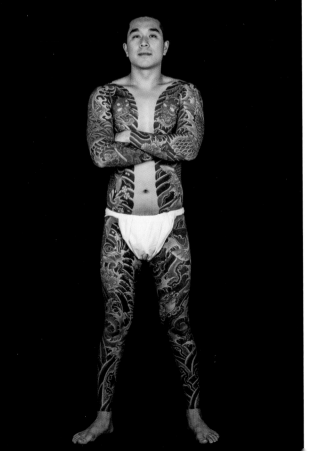

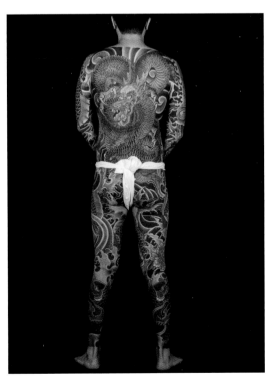

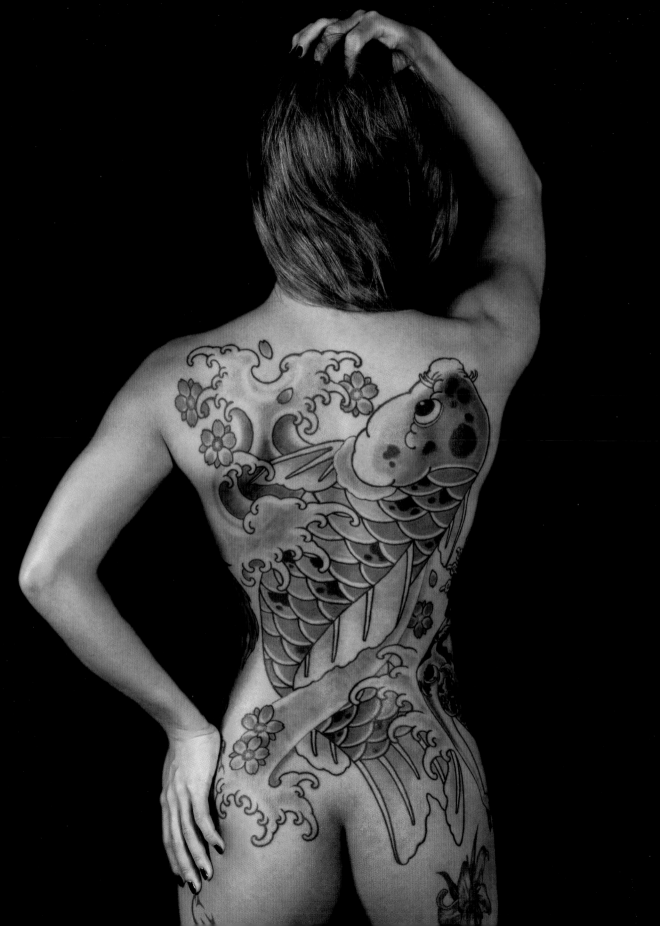

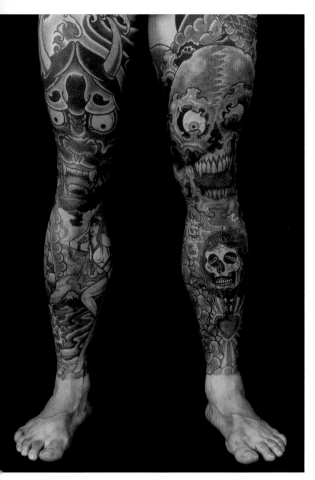

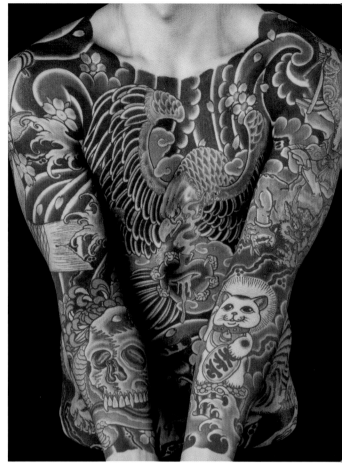

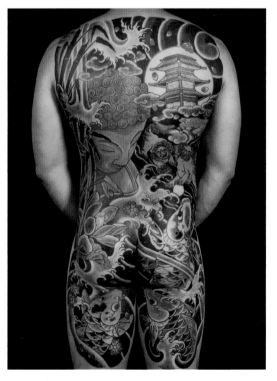

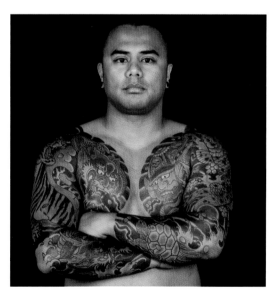

See more at www.little-tokyo.com.au
Rhys Gordon

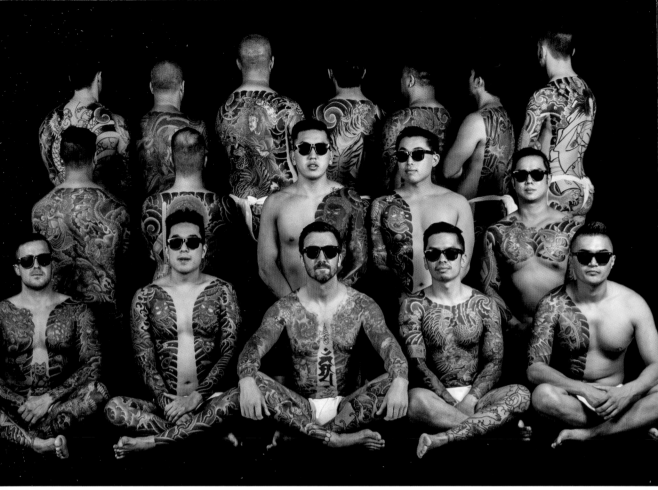

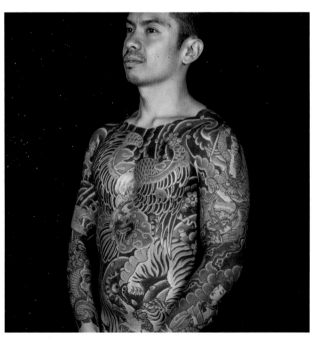

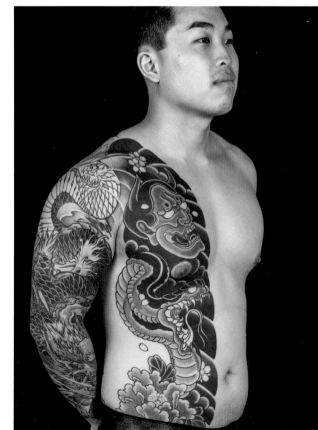

HENNING

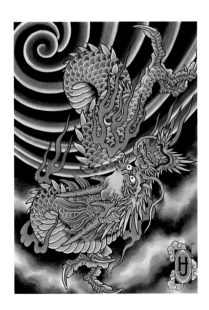

Henning began his tattoo education at the age of eighteen, starting in the red light district, and working his way through Nyhavn with the late Ole Hansen. In 1983 he founded Royal Tattoo, Denmark.

During his time in Copenhagen, Mike Malone (RIP), one of the best storytellers ever, inspired Henning to explore the tattoo scene internationally. This led Henning to travel around the world to learn as much as possible.

On his journey, he has been privileged to meet, talk and work with some of the best, if not the *absolute* best tattoo artists in the world. Some are legends in the industry, others are legends in his mind and some will become legends in the future, but for Henning they all became friends for life. Meeting Paul Jeffries in the late '80s was probably the biggest eye-opener for Henning: Paul's influence changed everything. Going to Japan and becoming friends with Mike Rubendall in the late '90s then took everything to a new dimension and added fresh energy to Henning's work.

Henning is forever grateful for the trust all his clients have in him. After thirty-six years, he is still passionate about tattooing and, if he had to start over, he would choose the same path again.

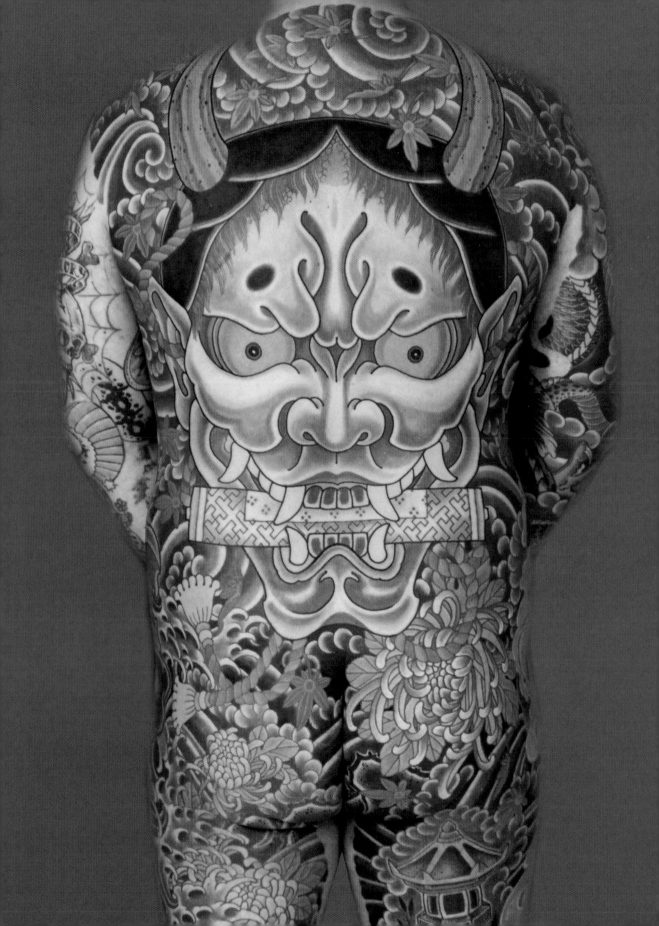

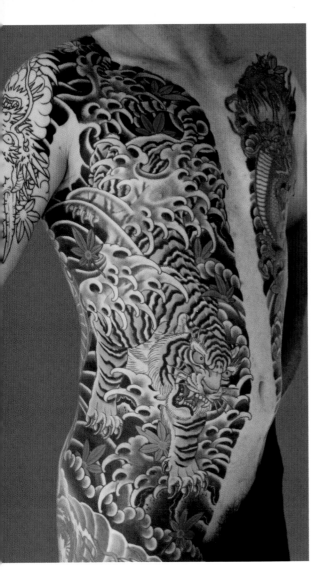

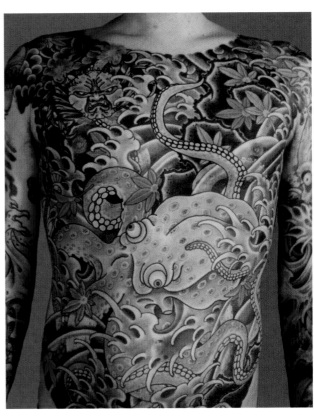

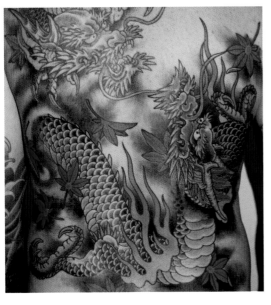

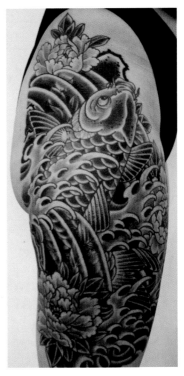

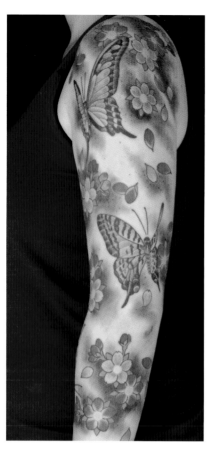
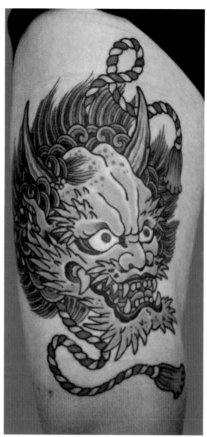
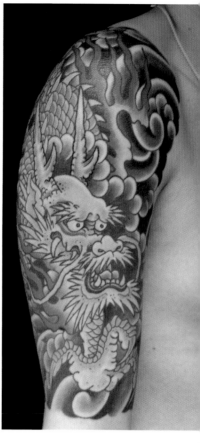
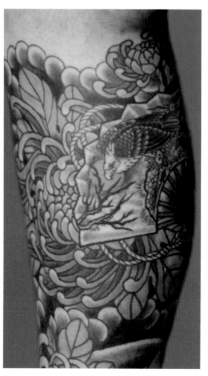
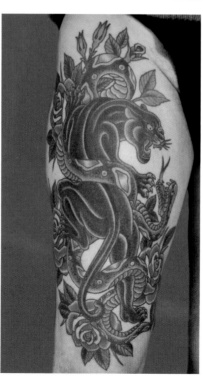
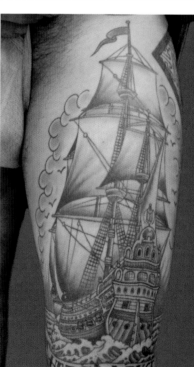

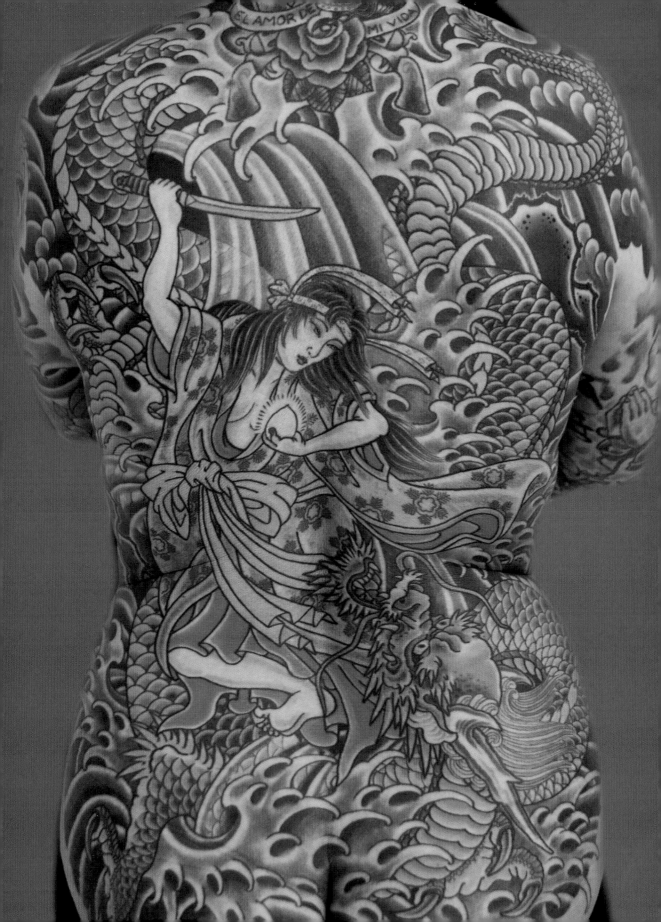

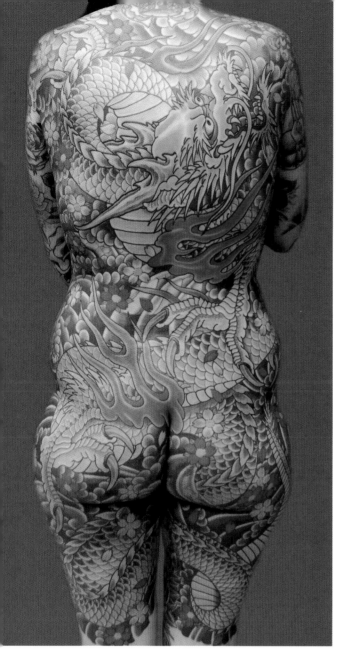

See more at www.royaltattoo.com

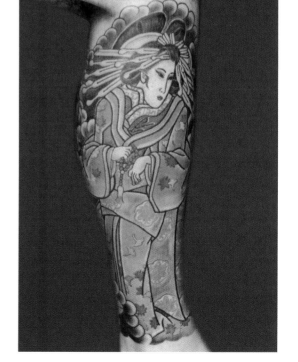

JOE
CAPOBIANCO

Famed worldwide for his unique pin-up 'gals',
Joe Capobianco is a familar face in the tattoo
world. His tattooing career started in a street
shop on Long Island, New York, in 1993 where he
primarily worked on everyday flash designs with
the occasional custom piece. His love of traditional
tattooing led to the style of tattoo that has become
the 'Joe Capo' hallmark.

As well as tattooing his artworks on skin, Joe
can be seen on the hit TV show *Best Ink* where
he is head judge. He has also developed a line of
tattoo pigments called Easy Glow, designed tattoo
machines, released two tattoo DVDs, created
toys, published six books and numerous prints.
His 'Capo Gal' and 'Blood Puddin' pin-ups are his
signature style.

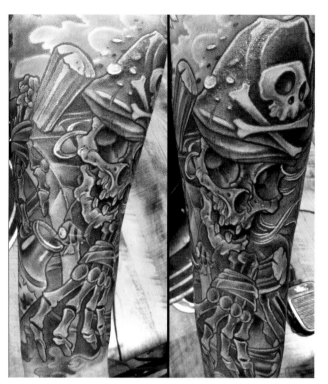

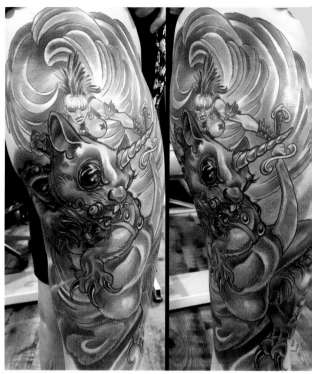

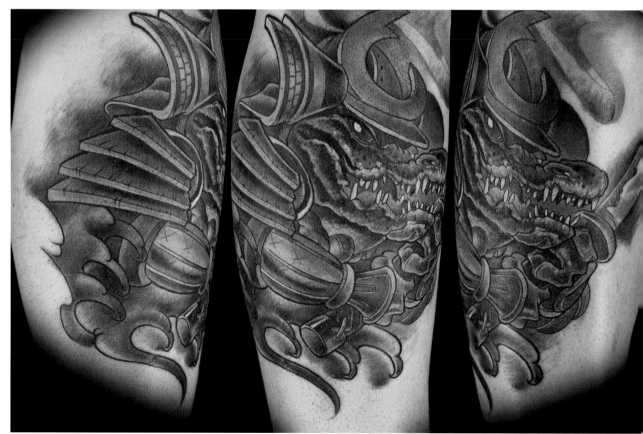

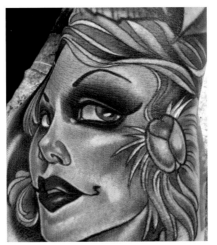
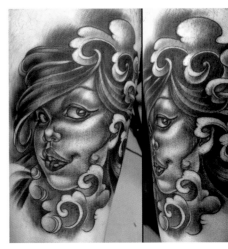
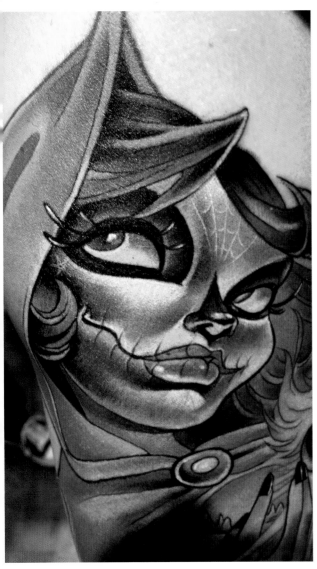
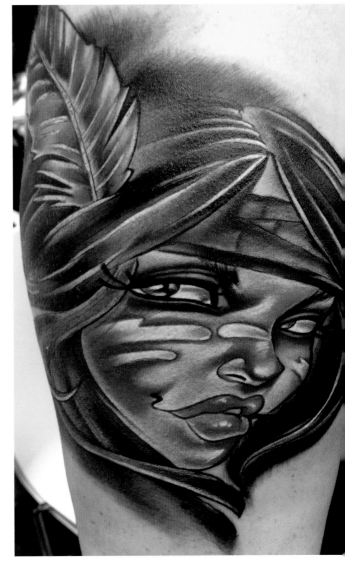

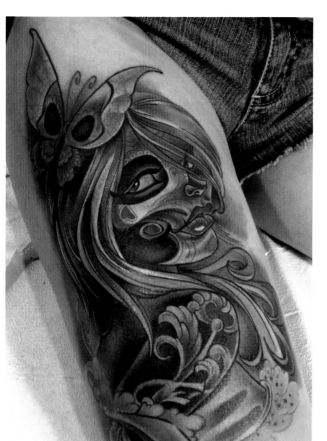

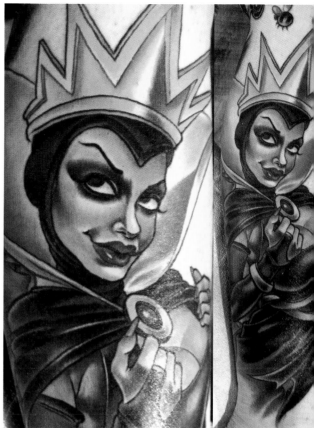

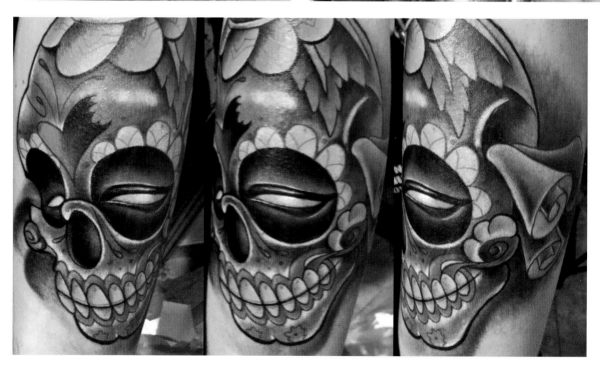

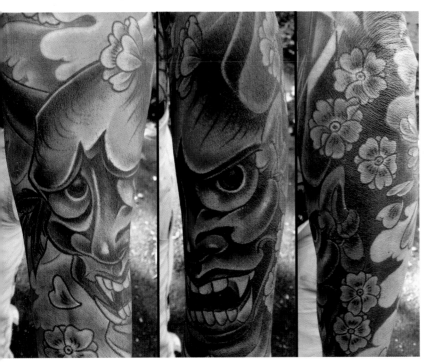

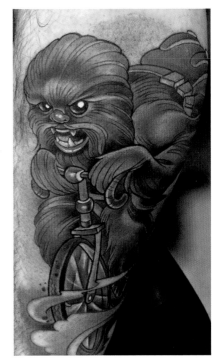

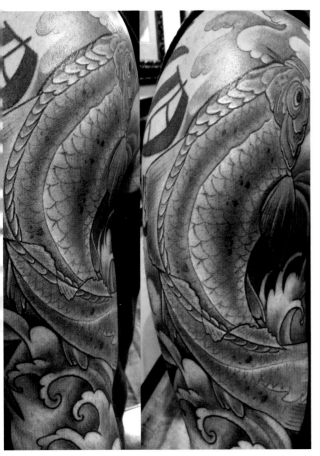

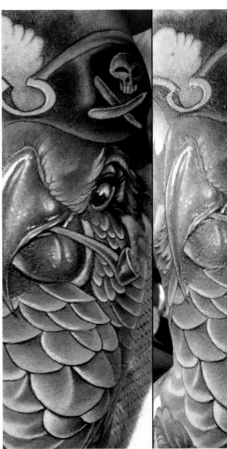

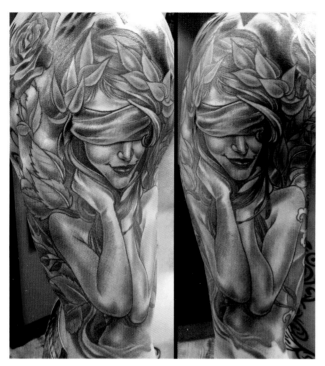

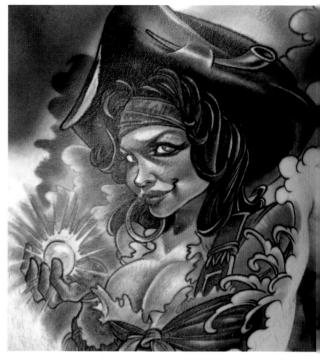

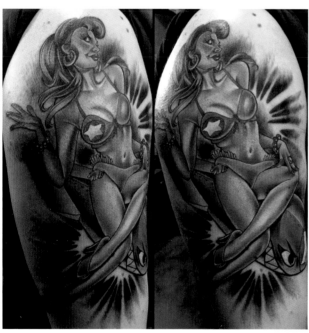

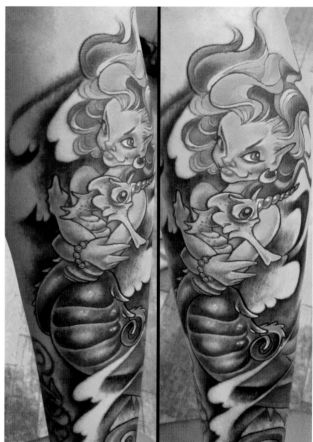

See more at www.joecapobianco.com

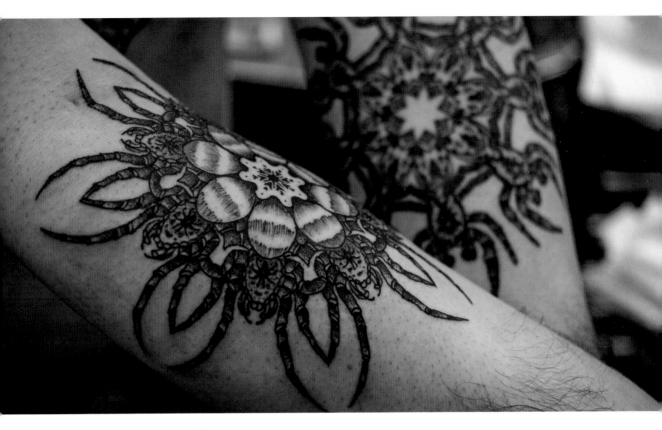

THOMAS
HOOPER

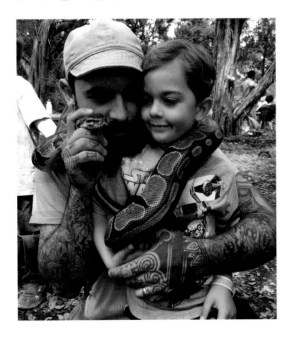

I live, paint and tattoo in Austin, Texas, and I'm husband to Kimberly Hooper, father to Clyde Walden Hooper.

After studying art and getting tattooed a lot, I decided fifteen years ago to try my best to learn how to make a decent tattoo. I have worked for Jim Macairt, Alex Binnie and Dante Di Massa, subsequently moving from England to New York City to work alongside Stephanie Tamez, Scott Campbell and Chris O'Donnell at Saved Tattoo. Now residing in Austin, I work at Rock of Ages, alongside Tony Hundahl and Steve Byrne.

Born in Hastings, East Sussex, I studied drawing at the London Institute of Art & Design. I am extremely grateful to have a very supportive family and such good friends from all over the world in my life, to have been given the opportunity to tattoo and to have such trusting and loyal customers.

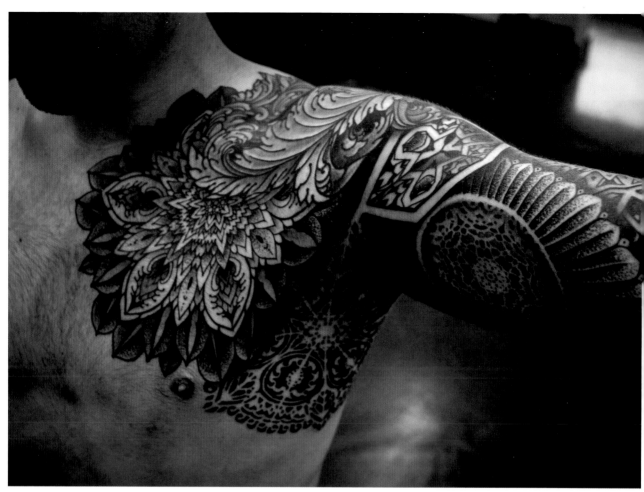

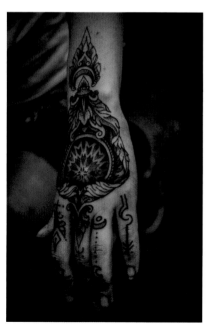

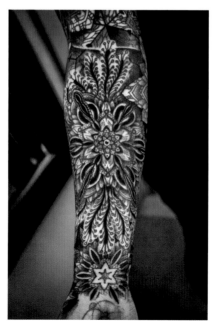

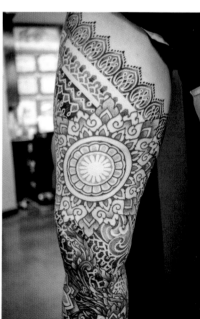

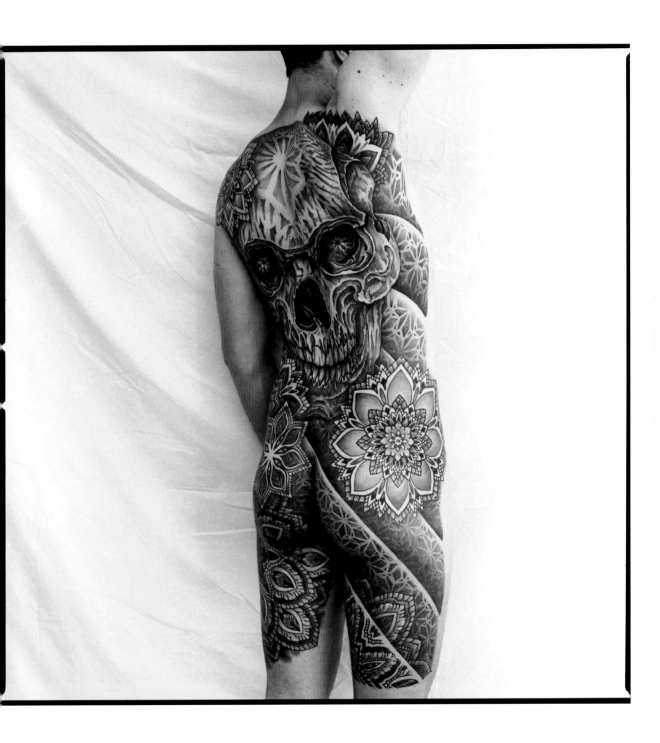

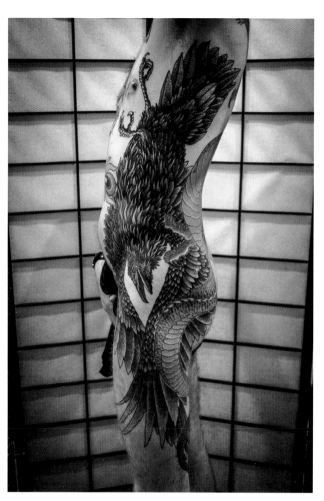

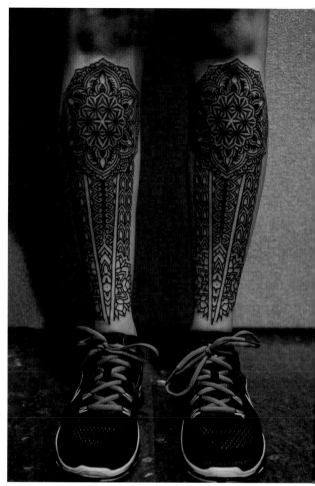

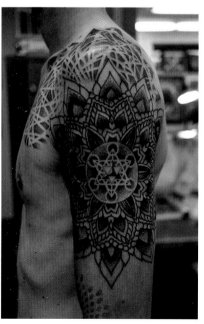

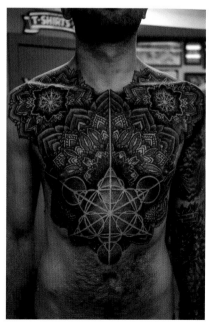

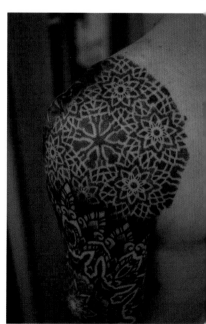

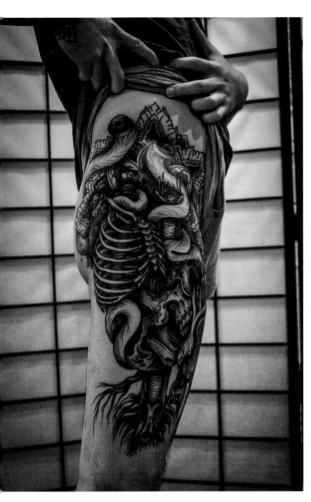

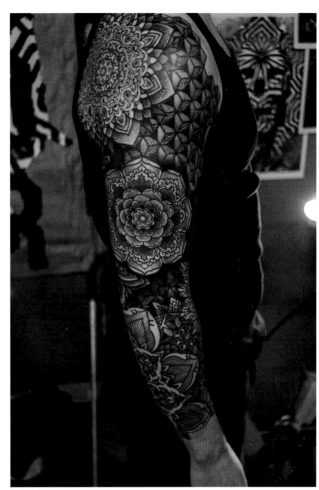

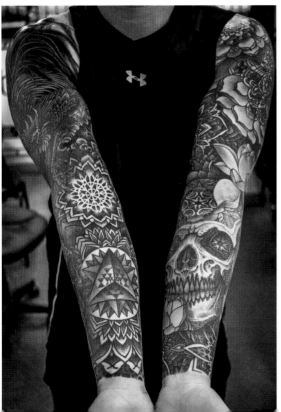

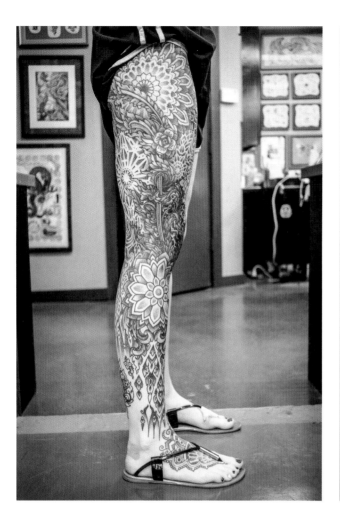

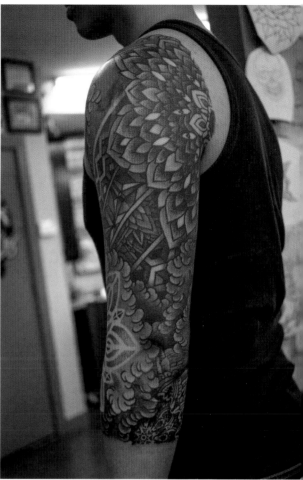

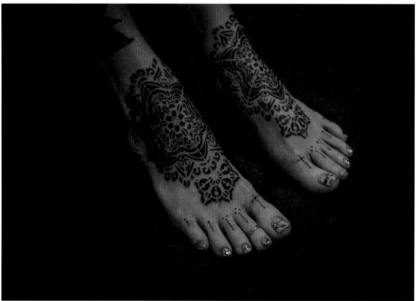

See more at
www.meditationsinatrament.com

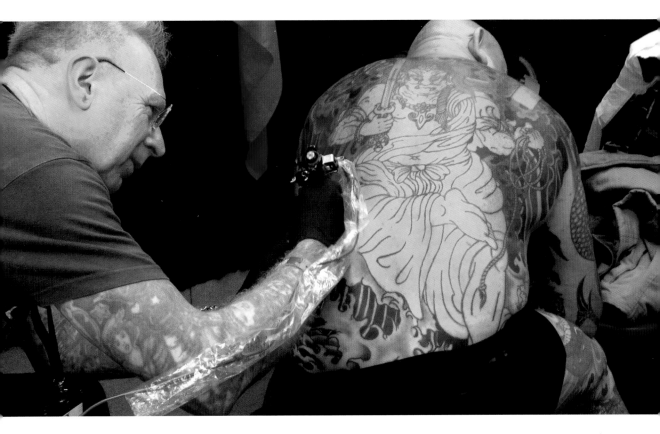

GEORGE BONE

George Bone is a living legend of London, British and world tattooing – situated in Hanwell, West London, he is famed for his large-scale Japanese tattoo works.

Having been tattooing for over fifty-four years, George has seen and mastered many of the genres of tattooing that have become popular over the decades. In the 1980s he gained plaudits for his gothic-inspired skulls and horror-theme tattooing, and for the sculptured skull and bone artefacts which he created.

George is a seasoned convention traveller, having visited many of them across the globe. A true ambassador for the ancient art of tattoo, his enthusiasm for his art and for tattooing continues unabated. It should also be noted that for a number of years George was recognized by the *Guinness Book of Records* as Britain's most tattooed man.

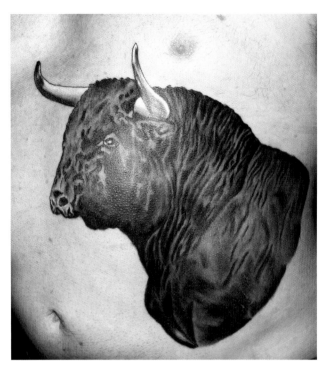

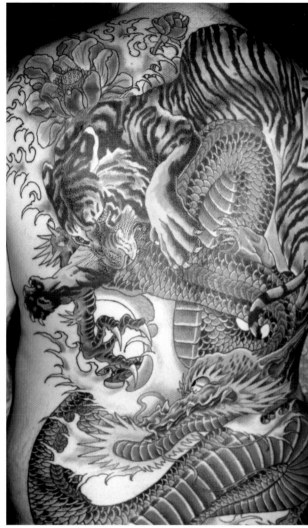

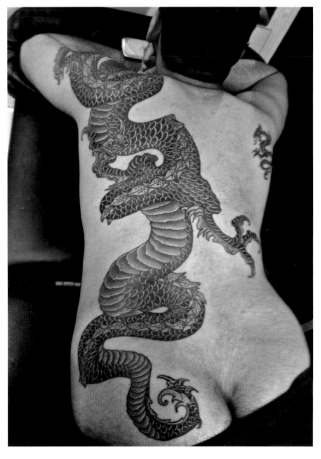

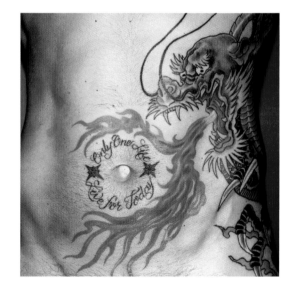

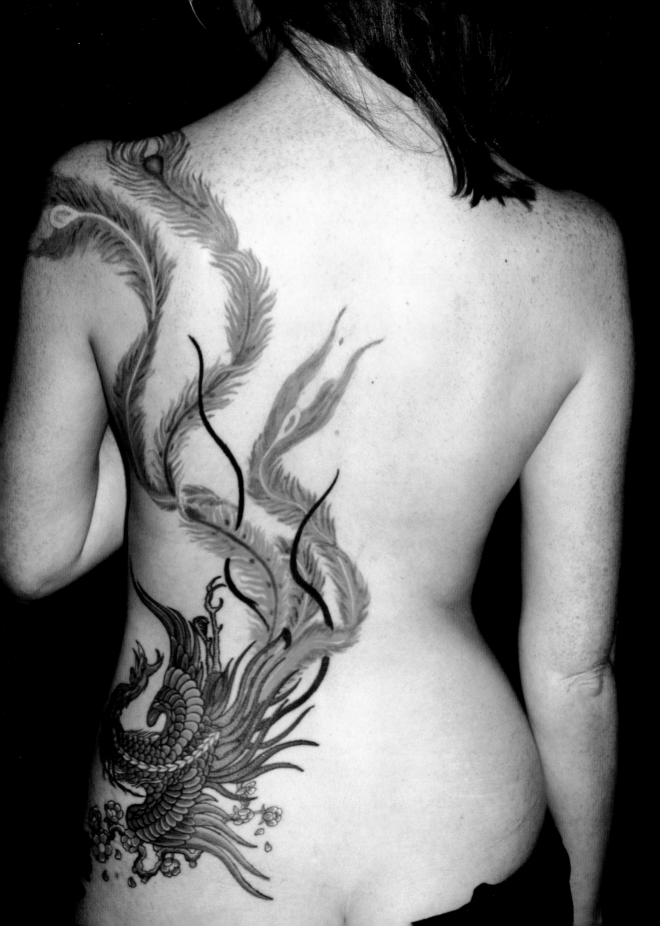

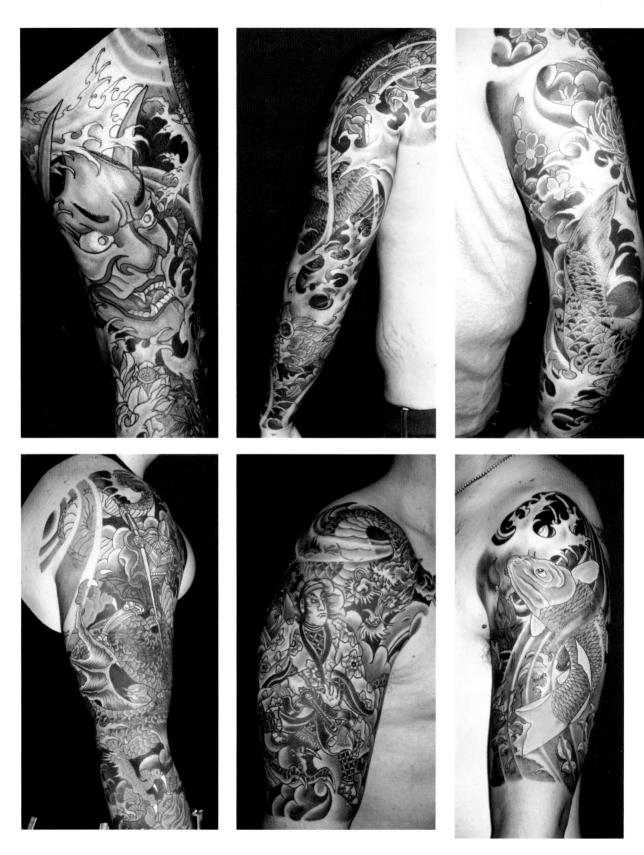

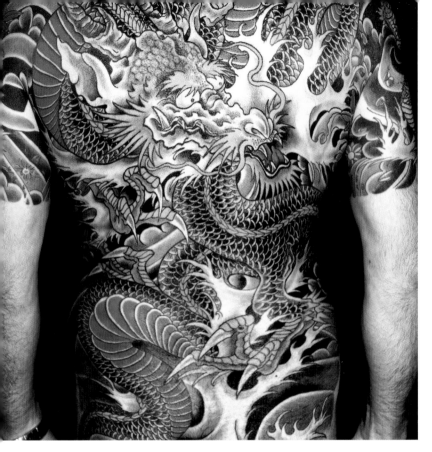

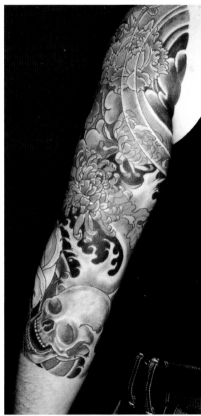

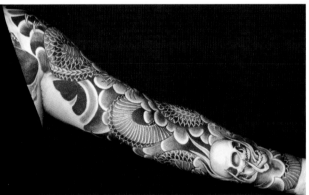

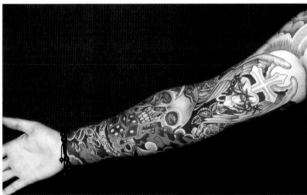

See more at www.georgebonetattoos.co.uk

DANIELLE
ROSE

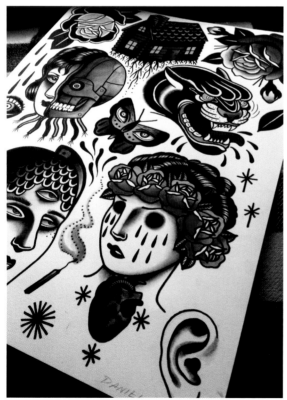

Danielle Rose, who has been tattooing for the relatively short time of five years, is another artist whose unique style has gained her international recognition. She originally worked in Perth, Scotland, on any type of tattooing 'that came through the door', it wasn't until Danielle took a break from the trade that she had time to actively draw and paint the things she was interested in, her main influences being cult films and TV shows, movie poster art from the 1970s and '80s and horror comics. These are the influences that led to the style seen in her art today.

After taking guest spots at OSC in Stourbridge and Sacred Electric in Leeds, Danielle decided to keep traveling and has been able to work at many studios as a guest artist on her journeys. She says, 'I feel very lucky to be part of a supportive industry. Since traveling, I've been able to see a lot of the world, but best of all I've been able to work with the most amazing people that have inspired me greatly.'

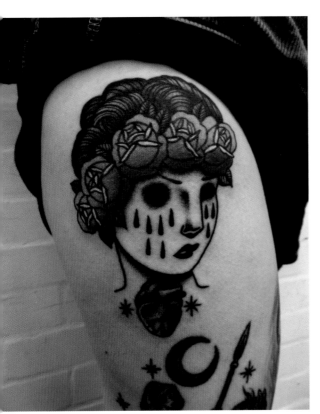

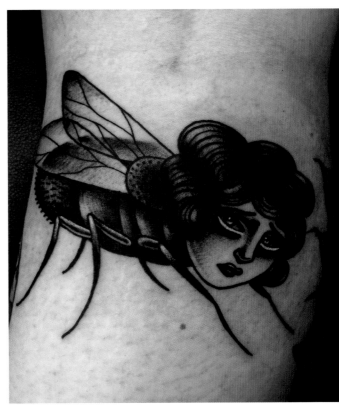

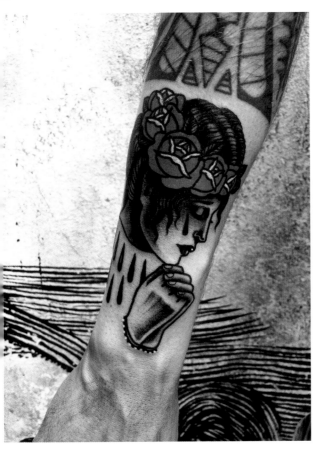

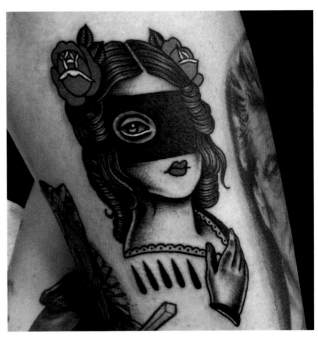

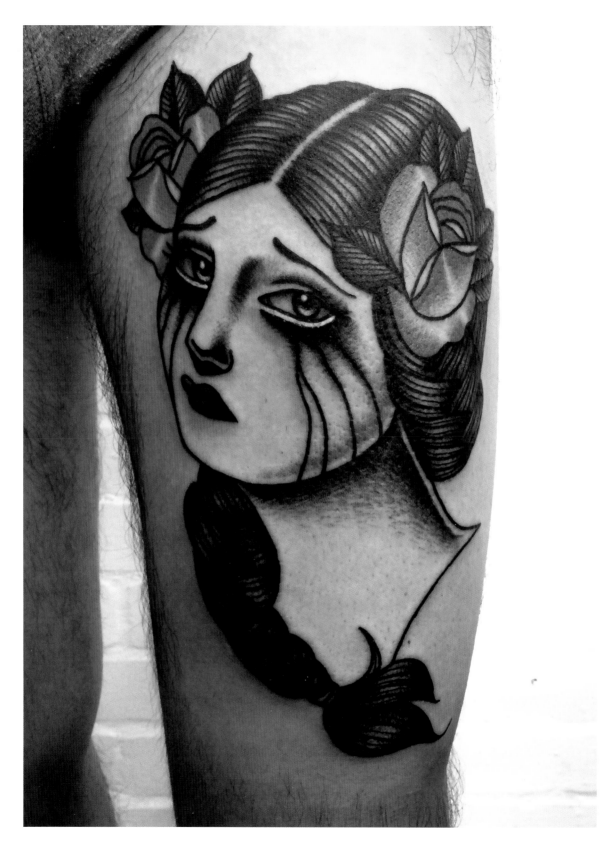

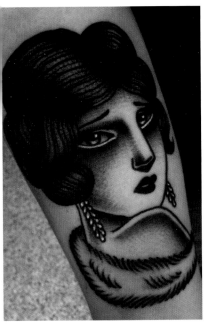

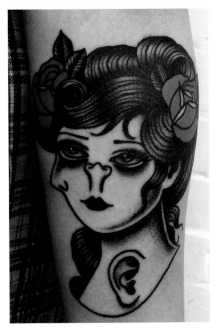

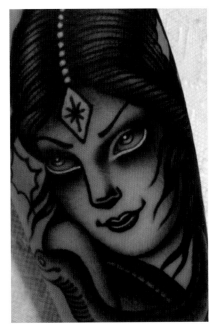

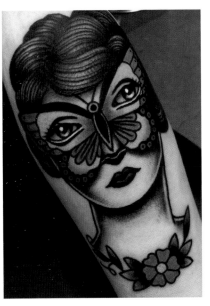

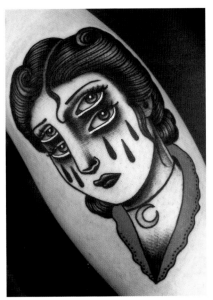

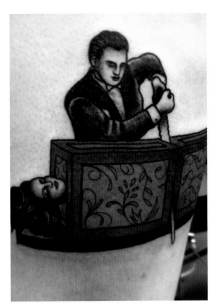

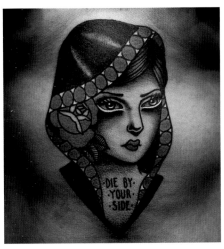

See more at www.instagram.com/daniellerose

DANIELLE ROSE 121

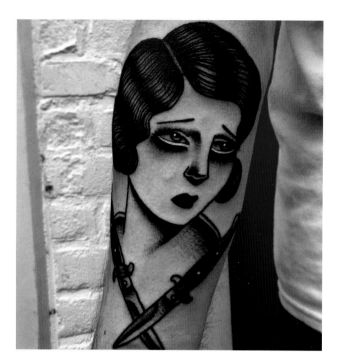

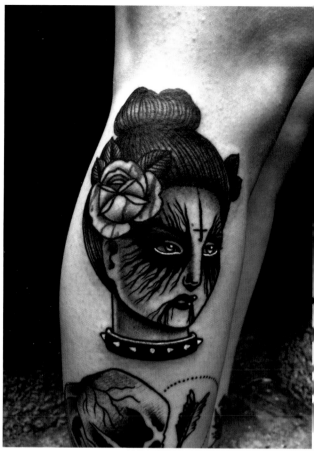

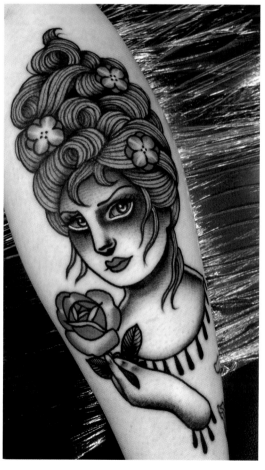

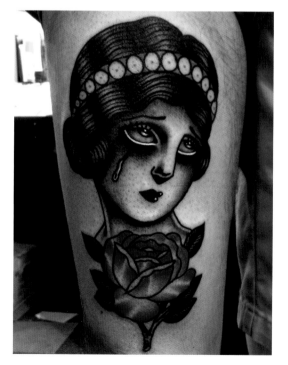

SAM FORD

Over the last ten years my respect and passion for tattooing has grown and continues to grow. With that comes the constant desire to learn and improve, meaning that I'll never be satisfied and I'll always be striving to be better. That's what I love about tattooing: it never gets any easier and there's always so much more to learn.

At the moment I tend to tattoo a lot of realism pieces, leaning towards more colour work than black and grey, although I love the challenges of both. I still don't feel like I've come close to perfecting my techniques, and each time I see new work from other artists I want to bring new elements to the way that I tattoo. It's constantly evolving and I'm not sure I'll ever conquer it but I love the challenge of improving my work each day.

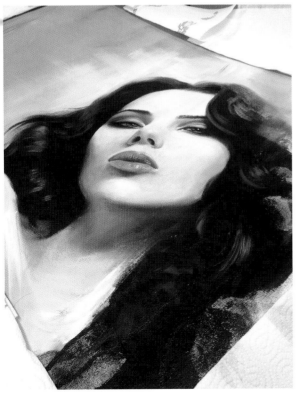

Since becoming a mum I feel my approach to tattooing has shifted for the better; I'm no longer working all the hours under the sun so I have time to stand back and reflect. I have a few bigger projects where I feel like I can experiment and possibly take a new direction. Luckily I'm fortunate enough to have awesome clients that allow me to do this and amazing artists I get to work with everyday to inspire me. I'm so excited to be a part of something that feels like it knows no bounds. It's liberating knowing that in the coming years I could travel the world and learn from the masters. Or I could immerse myself in painting and stretch myself creatively. I'm very proud and truly grateful to be a part of something that presents so many possibilities to me. I feel like I'm just getting started . . .

Sam Ford

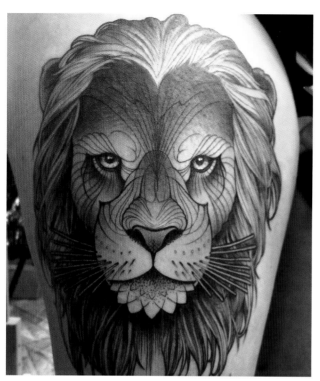

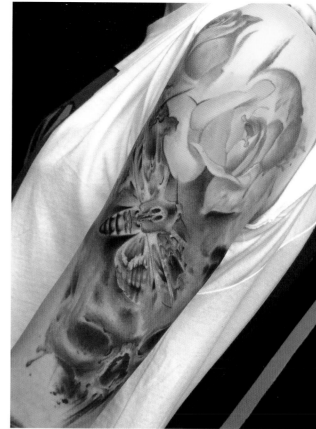

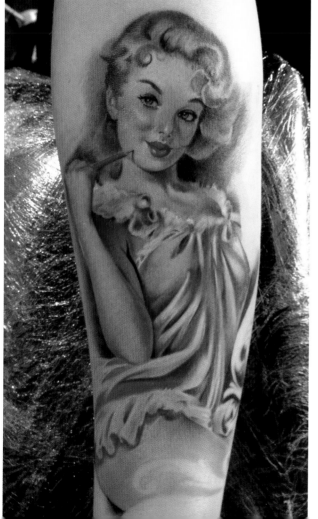

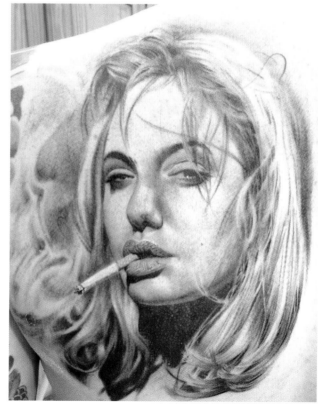

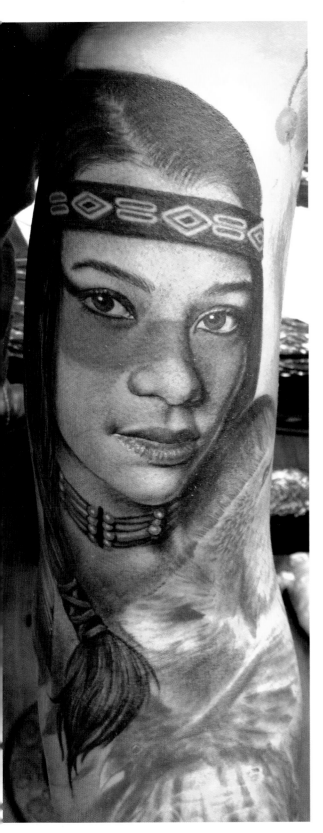

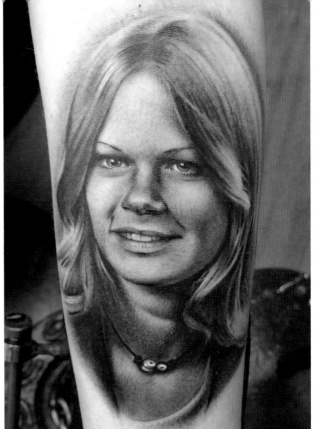

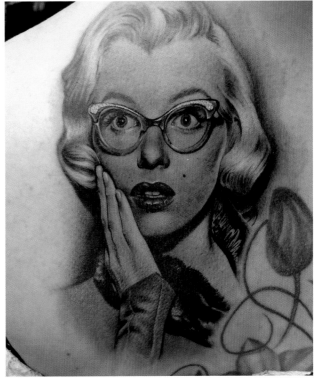

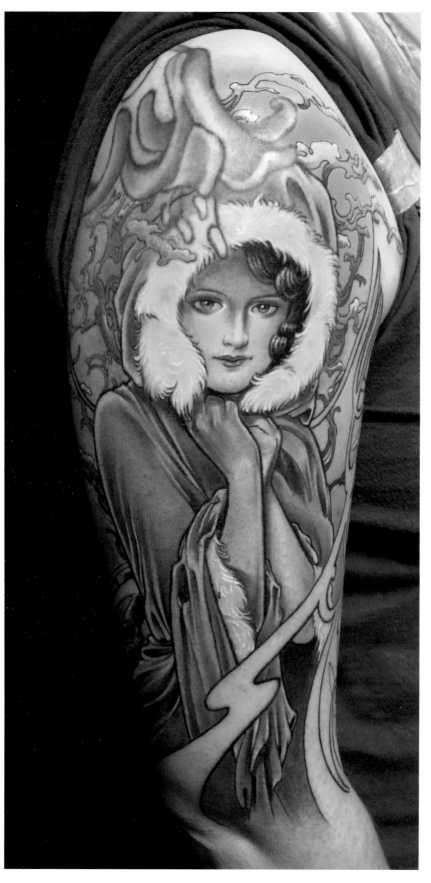
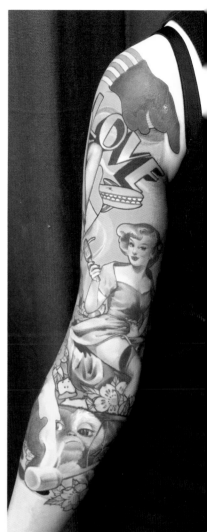

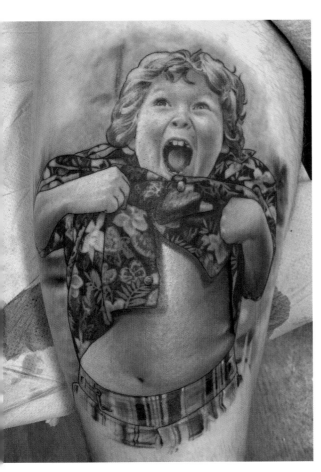

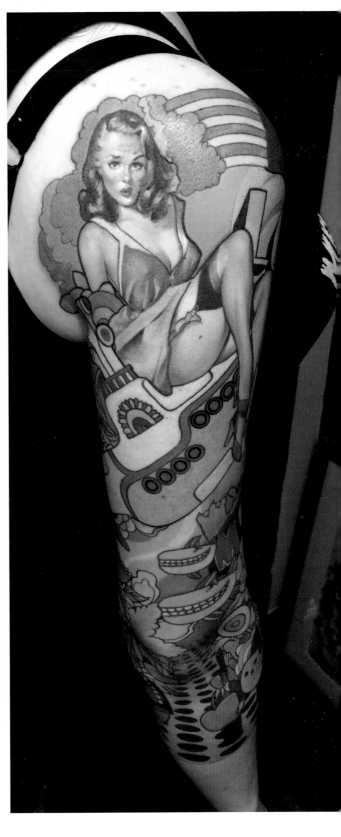

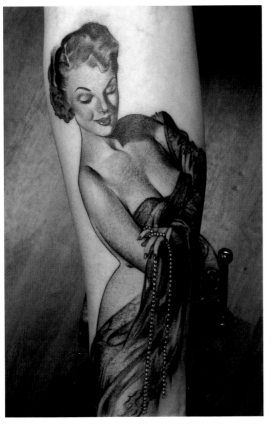

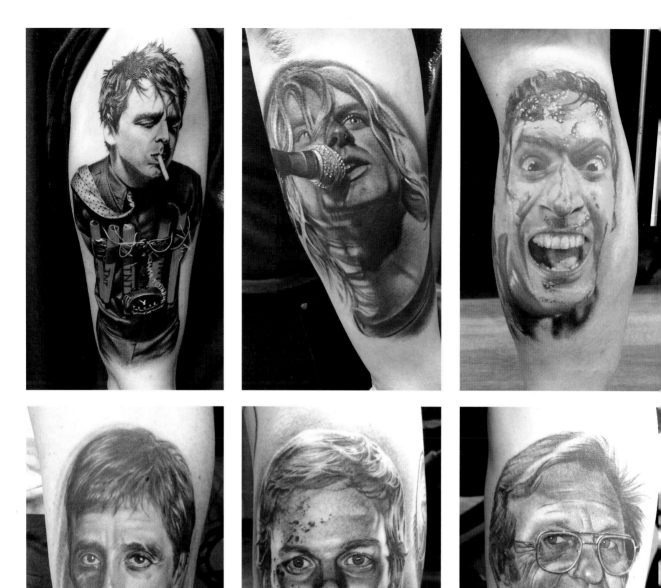

See more at www.facebook.com/samtattooartist